IMAGES
of America

NILES
FREMONT

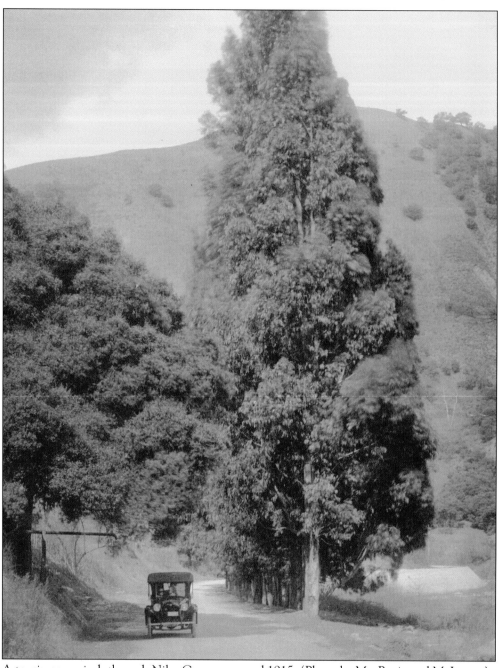

A touring car winds through Niles Canyon around 1915. (Photo by MacRorie and McLaren.)

Settled during the 1860s, Niles is one of those train towns that time, or at least the Bay Area, forgot. It is probably best known for being the first Hollywood. Charlie Chaplin and Bronco Billy lived here and made movies in the early 1900s. Broncho Billy shot over 300 silent westerns here, with so many classic train robbery and chase scenes shot in Niles Canyon. Charlie Chaplin shot his famous film The Tramp *right on Niles Blvd.*

—Michael McNevin, *Harbinger*, Winter 2000

IMAGES
of America

NILES
FREMONT

Philip Holmes
Jill M. Singleton

ARCADIA
PUBLISHING

Published by Arcadia Publishing
Charleston, South Carolina

Printed in the United States of America

Library of Congress Catalog Card Number: 2004106571

For all general information contact Arcadia Publishing at:
Telephone 843-853-2070
Fax 843-853-0044
E-mail sales@arcadiapublishing.com
For customer service and orders:
Toll-Free 1-888-313-2665

Visit us on the Internet at www.arcadiapublishing.com

This book is dedicated to Louise Holmes.

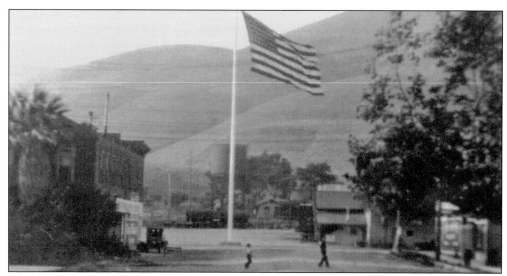

The Niles Memorial Flagpole, pictured here at the end of World War I, is an 80-foot-tall landmark financed by the Niles community, reconstructed May 17, 2004, and formally rededicated by the community with music, speeches, and ceremonies on June 12, 2004.

To be sure, Niles is part suburb and part sticks, and it has a good cross section of families, working people, hippies, hicks, old-timers, bikers and artists. Downtown proper is only five or six blocks long, with a flag pole in the center that was once the mast of an old sailing ship. Railroad land takes up a lot of the main drag, so it's still mostly a one-sided main street, creating a great view of the old hills, the passing freights, the train station, and the huge white cement-block "Niles" sign on the big hill above town. Lining 2nd and 3rd streets are a lot of Victorians and other funky old houses from past eras. The roots run deep here and many of the homes and buildings, and much of the land, have been owned by the same families for generations.

—Michael McNevin, *Harbinger*, Winter 2000

4

CONTENTS

ACKNOWLEDGMENTS

We would especially like to acknowledge David Kiehn for enriching every step of this project, and helping to keep the lens focused. We truly appreciate the steady support of B.J. Bunting, Julianne McDonald Howe, and Bruce Roeding. Thank you for all of your help.

We would like to thank all those that gave their time, support, and shared their stories and resources over the years, including Chet Amyx, Harry Avila, Lila Bringhurst, Herb Cartwright, Bruce Cates, Marvin Collins, Michael Corbett, Mark Crutcher, Don Dewey, the De Guilio family, Ward Hill, Inge Horton, Dr. Walter Hughes, Cindy and Barry Jennings, Joan and Art Kimber, Nelson Kirk, Al Lopez, Laurie Manuel, Kenneth Manuel, Kely McKeown, Michael McNevin, Al Minard, Nancy Minicucci, Woody Minor, Natalie and David Munn, Mary Nunes, Myrla Raymundo, Susie Richardson, George Roeding III, James Shinn, Jennifer and Maurice Silva, Janice Stern, Maj. Gen. John F. Stewart Jr., Charles Sullivan, Frank Williamson, Wendy Winsted, and many other friends of Niles past and present.

We would like to thank Martin Killgallon of the Ohio Art Company for permission to include photographs of Etch A Sketch® used by Michael McNevin in his nostalgic drawings of Niles. The Etch A Sketch® product name and the configuration of the Etch A Sketch® product are registered trademarks owned by The Ohio Art Company.

All photographs are part of the Dr. Robert B. Fisher Collection, Museum of Local History (MLH), located at 190 Anza Street, Fremont, California 94539, unless otherwise credited. The photographs from the Niles Essanay Silent Film Museum are noted as NESFM and their use is greatly appreciated. We would like to thank all those who contributed the use of their photographs for this volume; we could not have done it without you.

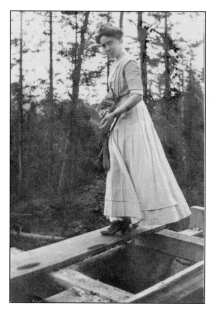

This image finds Laura Thane Whipple with her new lightweight folding Kodak camera. A true visionary, she was the inspiration behind the U.S. Navy's selection of 1,700 acres for the Sunnyvale Naval Air Station to house the latest technology in dirigibles and airships in 1930. Opened in 1933, it became NAS Moffett Field. By the mid-1950s the growth brought Lockheed's missile and space division and the NASA Ames Research Center to the Bay Area. Before Whipple's death in 1966, her pioneering vision was celebrated by the declaration of Laura Thane Whipple Day at Moffett Field.

INTRODUCTION

Niles has celebrated its own uniqueness ever since it first began as "El Molino" (The Mill) in 1840. The mill ruins can still be seen at the intersection of Route 238 and 84 at the mouth of Niles Canyon. With a good climb one can look down on the town of Niles, along with the cows that graze on the hills. Bring some camp coffee and the view is not very different from what the Essanay crew saw while making the 1914 silent western, *When Love and Honor Called*, shown on the cover of this book.

The several railroad wyes of Niles could be seen easily in 1914 too, as could the one-sided railroad layout and its grid of neighbor streets. The railroad names have changed, the neighborhoods have filled in with homes, the industries and businesses have evolved, and the trees have grown tall. The gateways to downtown Niles are still the same railroad subways built in 1937 when the highway bypassed the town. Today, short and long loop trails through the reclaimed quarries and regional trails also wrap about Niles. They await discovery by cyclists and foot travelers alike. They arrive by steam train and come by bicycle. So bring your motorcar and discover Niles for yourself. This book is just a start.

The stories of waterways, railways, wagon ways, country ways, and highways that meet and intersect at Niles are documented here. Photographers since the 1880s have been recording Niles Canyon, Vallejo Mills, and Niles. Not all the stories can be told; nor do they all match existing photographs, and not all the mysteries can be solved. Images by photographers as diverse as Gabriel Moulin of San Francisco, Charles Allen Dealey of the Essanay Studios, and others who grew up in Niles, such as Julianne MacDonald Howe, are just a beginning to the exploration of the history of Niles.

Niles can lay claim to many firsts—and lasts—in California. Famous bandit Joaquin Murrieta may have unwittingly spent his last night here. The first and last operating, fully engineered, water-powered grist mill was here. Niles was also the location of the first dam and aqueduct in the state, and the Hetch Hetchy Aqueduct in the 1920s. It boasted the first public trail to be built on a levee by the U.S. Army Corps of Engineers, as well as the first use of fabridams on a waterway around 1970. Niles attracted the first gravel mining operation in 1868, and was the last transcontinental railroad link in 1869. Niles produced the first garden book (1879) and the first horticultural agribusiness (incorporated here in 1884), and the first chain of garden retail centers was pioneered here in 1930. In 1924 Niles became home to the first poultry genetics-breeding farm. It also had the first female editor of a California literary journal (1883) and the first female Ph.D. graduate of the University of California (1898). Aviation pioneer Allen Loughead was born here, as was 1992 Olympic gold medal skater Kristi Yamaguchi. The first Thai Temple in California was built here in the 1990s and the largest Sikh temple in 1993.

But more often Niles is known for having had the first movie studios in Northern California, beginning in 1912. Among the many films made here is Charlie Chaplin's best-known film, *The Tramp*, which used Niles streets and sidewalks as sets. Famous cowboy star Broncho Billy starred in and produced hundreds of Westerns on Niles hillsides and canyons.

Niles had its own firsts as well. The first vineyards were planted by 1850 and the area already had the grist mill mentioned above. In the 1860s came the first local railroad, nursery, and the town plat. In the 1870s the town got its first station depot, the initial wagon bridge over Alameda Creek, and earliest school at Vallejo Mills. The 1880s brought the first church, the last

operation of the grist mills, and the first town hall. In the 1890s came the first big freeze to impact local orchards. The turn of the century brought the first free library, bank, and movie theater. In the 1910s Niles got its first grammar school on School Street, along with a kindergarten, and a courthouse. The Roaring Twenties brought the earliest tile factory and the 1930s, the first motel court and steel plant. In the 1940s the last passenger train stopped in downtown Niles and the first person saw the ghost of Niles Canyon. The 1950s brought in with it the first female city council member and the inaugural Essanay Days Parade. In the 1960s came the first Annual Niles Flea Market and Antique Faire, and the first Jewish temple. The 1970s was the decade of the last passenger run of the California Zephyr through Niles Canyon. The 1980s, sadly, saw the last Niles train station moved but happily witnessed the first rebuilding of track for the Niles Canyon Railway in Niles Canyon. As it approached another turn of century, in the 1990s Niles held its inaugural Niles Dog Show, Broncho Billy Film Festival, and Wildflower and Art Festival, and the first Niles Canyon Railway steam train roared over Mission Boulevard into downtown Niles.

The events mentioned here, like the images in this book, are just highlights, bright recognizable signposts that help us ride the rails of time back into Niles history. Travel at your own speed and stop off at any time to enjoy the view. Have a good journey.

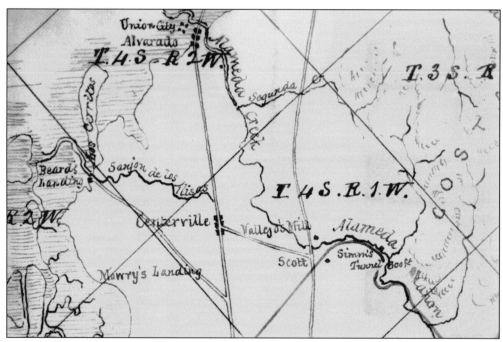

The extensive lands north of Alameda Creek comprised the Rancho Arroyo de la Alameda granted to Don Jose de Jesus Vallejo in 1841 and were confirmed by President James Buchanan in 1858. The rancho covered 17,705 acres and ran up to 10,000 head of cattle. The first Western Pacific Railroad was constructed, under the lead of Charles McLaughlin, from San Jose to Farwell in Niles Canyon during 1865 and 1866. It was built on the former Mission San Jose lands, bypassing entirely the rancho lands of Vallejo owned by Jonas Clark in 1863. This rail route was acquired by Gov. Leland Stanford to complete the transcontinental railroad in 1869, and was known for years after as the "Governor's Road."

One

MILL TOWN
1840–1894

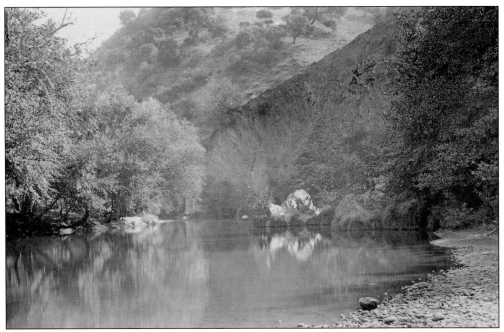

On March 31, 1776, Capt. Juan Bautista de Anza and his small expeditionary force surveyed the East Bay on horseback, crossing the Arroyo de la Alameda at a natural ford at the mouth of Alameda Cañon. Father Font described the crossing in his diary: "About halfway on the road we came to an arroyo with little water, most of it in very deep pools. It has on its banks many sycamores, cottonwoods, and some live oaks and other trees, and it appears to flow west to empty into the estuary . . ." The expedition traveled 10 long leagues that day before camping in the area of Hayward.

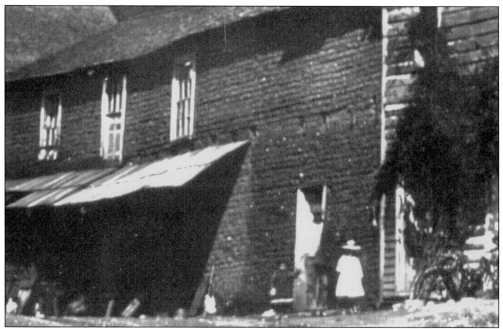

This photograph of the two-story adobe grist mill, built in 1841, was taken in the early 1880s. In a taped interview in 1966, Laura Thane Whipple identified the girl in the white dress as her little sister Hazel. The Thanes moved to Niles from San Francisco in 1882 to bring up their family in the country. Mrs. Thane's father, Judge Tilden, had purchased an orchard and an 1875 Greek Revival house built by blacksmith Thomas Bedard. Mr. Thane commuted by rail to Oakland where he ran an insurance business.

In the early 1900s the Spring Valley Water Company of San Francisco raised the dam in Niles Canyon for its own purposes and it became an even more popular swimming hole, as seen here. In the 1820s J.J. Vallejo had worked as overseer for his father, Ignacio Vallejo, at Rancho Bolsa de San Cayetano near Monterey, inheriting it in 1832. His father was responsible for irrigation systems at several missions before retiring in 1823. The mills, granite dam, and two-mile wooden flume on Alameda Creek originate from this engineering legacy.

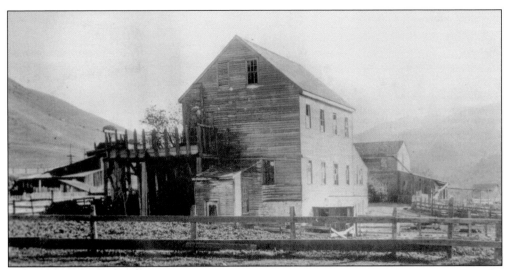

The first set of millstones used in the 1841 mill came from the Vallejo rancho in Monterey. The next three millstones were ordered in 1853 and arrived in 1856. Vallejo then contracted with Sylvester Amos of Harford County, Maryland, to build a new overshot design with a wooden wheel over 20 feet in diameter. (Still standing in Harford County today is a similar mill built around 1800 by an Irish miller. It is called the Amos Mill.) The redwood timbers of the 1856 mill above were rumored to have been reused in the Domenici apartment flats at Second and J Streets in Niles. The Italian vegetable gardens of Manuel Domenici grew in the fertile soil around the old mill race around 1900.

In 1869 the mills were leased for a year by the Central Pacific Railroad while the creek was torn up for rail bed construction; the CPRR rebuilt the aqueduct with masonry. In the same year, Plutarco Vallejo, son of J.J. Vallejo, a mining engineer and graduate of Santa Clara College (predecessor to Santa Clara University), contracted with surveyor Luis Castro to lay out the first subdivision plat of 23 small lots around existing mill buildings and dwellings; the subdivision was recorded as Vallejo Mills.

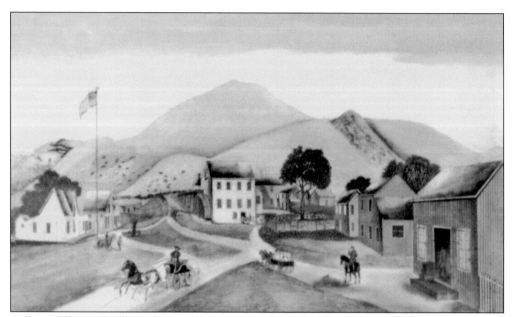

Vallejo Mills may be the earliest mill town in Northern California. This watercolor was painted after completion of the second mill in 1856 by Plutarco's teenage sister Carmelita, who was then finishing her studies at the Notre Dame Academy in San Jose (still a girl's school today). The Gothic-style houses on the left were delivered around the Horn about 1853, as were similar houses ordered from Boston by Carmelita's uncle, Gen. Mariano Vallejo. This is the first documented flagpole in the Niles area.

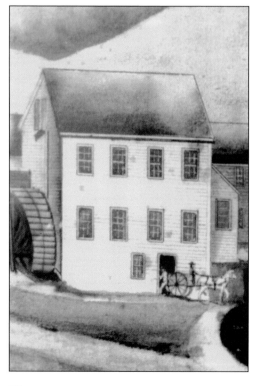

Passing near Vallejo's Mill last week we took occasion to step in and glance at the machinery and interior arrangements, and were well pleased with the visit. An old friend, Mr. Johnson, did the honors of the establishment and explained to us the improvements in the machinery. We saw it in operation for a few moments and were surprised at the steadiness and evenness with which the ponderous wheels revolved, and the various contrivances worked their respective offices without jar or noise. The water wheel is an overshot, 30 feet in diameter and 8 feet broad. There is sufficient water all the year around to turn the run of stone, four feet in diameter. The mill has a capacity to turn out 150 barrels of flour per day and it cost $5000.00. The mill is beautifully situated at the mouth of the gorge through which the Alameda Creek comes out of the mountains, and being skirted by a region unsurpassed in the world for fertility cannot fail to be remunerative. Mr. Vallejo deserves the highest credit for the enterprise and judgment manifested in his work and his spirit of go-aheaditiveness is quite a type of young America.

—*Alameda County Gazette*, January 7, 1857

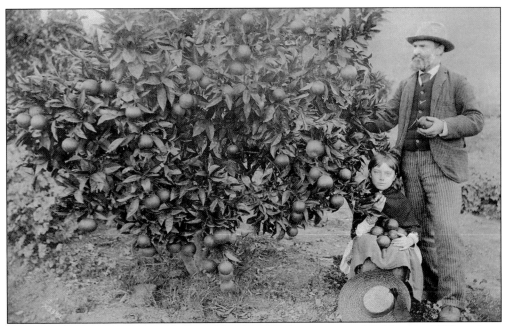

Harrison Mayhew, briefly mayor of Brooklyn before it became part of Oakland in 1872, took on the life of a gentleman farmer and retired from his grain merchant business. He purchased the lands next to Vallejo Mills in 1882 from Jonas Clark, building his house above Niles Station before there was a town of Niles. He is shown here with his daughter Florence Mayhew in his orange orchard that thrived on the soil of the old cattle corrals.

Joaquin Murieta may have known Alameda Cañon long before his outlaw life from 1850 to 1853. His relatives may have lived here; another history says a Vallejo half-brother lived in this adobe. Joaquin may have slept here and rounded up horses for the Vallejo family, though whether here or at Monterey is not clear in the stories. In 1866 this adobe became part of Rankin Ranch on Vargas Plateau. The wood shingle roof, board lean-to, and the outside wooden stair were recorded in this photograph taken by Overacker around 1890. The adobe gradually disappeared, but the legend lives on. (Courtesy NESFM.)

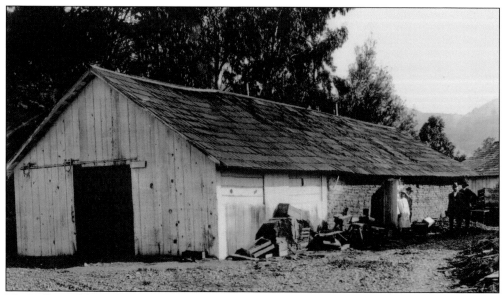

The Vallejo adobe is shown here around 1890 with its shingle roof intact; John Rock, owner and manager of the newly incorporated California Nursery Company, was using it as a fumigating house. It would have been a new and windowless granary with a shingle roof and one low door when American soldiers were directed by Col. John C. Fremont to commandeer food and other supplies at Vallejo Mills in 1846.

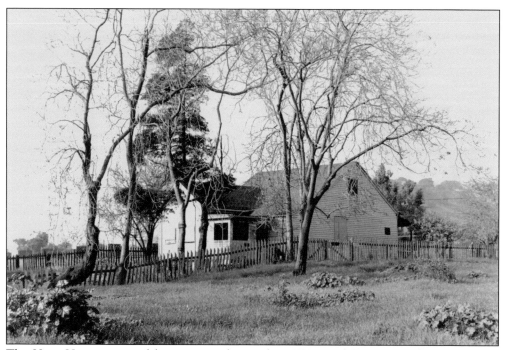

The Hunt House, pictured here, survived into the 1970s until Fremont undertook its first redevelopment agency project in 1972; much of Vallejo Mill old town was cleared away. Alameda Creek formed the southern rancho boundary, and a decade later the creek became the boundary between Contra Costa and Santa Clara Counties.

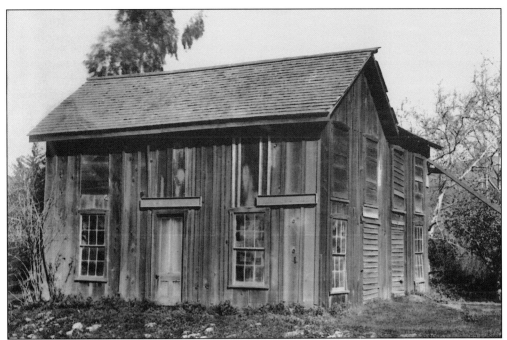

This blacksmith building dates to 1856 and was essential to the mill works. The overshot mill design was the most efficient engineering design available for a small water-powered mill, requiring extra strength in the building timbers to offset the forces it created. The moving parts were a mixture of hardwood and iron, with wood and iron gears meshing together in places to power several pairs of millstones working at once. In the 1870s the blacksmith was French Canadian Thomas Bedard, but by 1878 it was a Mr. Hinckley.

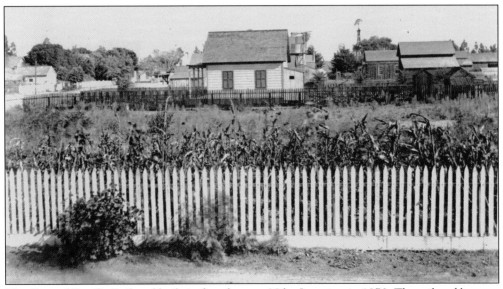

The Central Pacific Railroad built its first depot at Niles Junction in 1870. The railroad became the Southern Pacific in 1884, and formally recorded the Niles town plat in 1888. These homes with their gardens and water tanks are part of "old town" on Vallejo Street, some remnants of which still exist today.

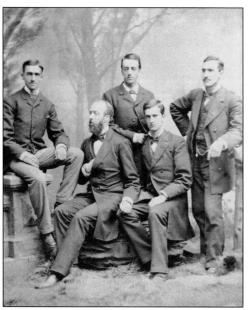

The Shinns sent their children to attend high school in Oakland, where their cousins lived. They were among the first students at the University of California at Berkeley, where their English professor was poet Rowland Sill. This 1880s photograph shows the cousins, from left to right: (front row) Charles Howard Shinn (poet, journalist, and forester) and Edmund Clark Sanford (poet, psychologist, and president of Clark University); (back row) Mervin Clark, Joseph Clark Shinn (agriculturalist and water district founder), and J. Fessenden Clark.

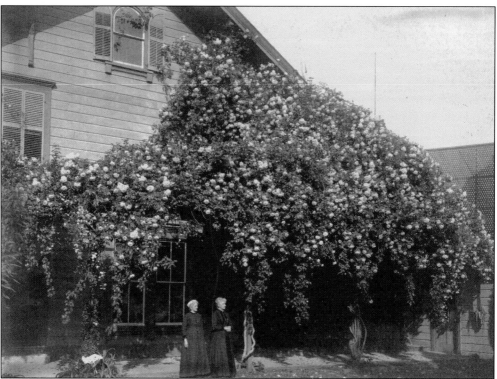

In this 1890 photograph Lucy Shinn and her sister-in-law Lucy Clark appear under the La Marque roses covering the Shinn's 1876 house. Lucy and James Shinn settled at Alameda Creek in 1856, shortly after Alameda County was formed. They established some of the first orchards in the county and were one of the earliest nurseries in the West to import plants from Asia. In his *Pacific Rural Handbook* of 1879, the first garden book published on the West Coast, author Charles Shinn recommended "scrapings from the chicken-yard" as the best fertilizer for roses.

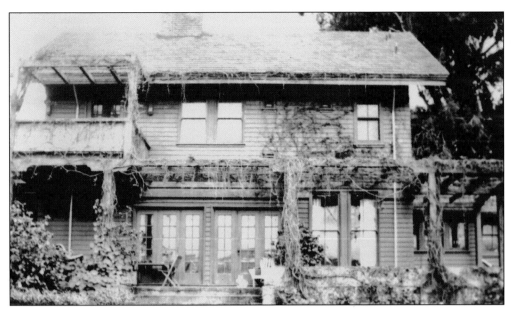

In 1915 Milicent Washburn Shinn commissioned Berkeley architect Lilian Bridgman to design a house for her near Alameda Creek, not far from the new Western Pacific station at Niles. Later her cousin Martha Sanford was killed on this track driving her new automobile, the first such fatality in the area. The house was moved in the 1950s to Peralta Boulevard where it stands today, east of the main Shinn House. One of the millstones from Vallejo Mills was apparently built into the porch.

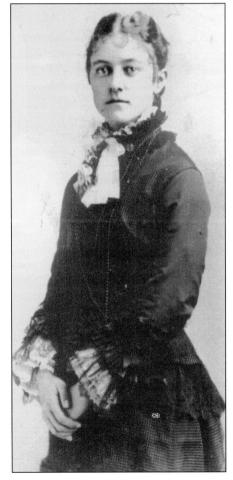

Milicent Washburn Shinn was editor of the San Francisco–based literary journal *Overland Monthly* from 1882 to 1894. She also published stories, poems, and journalism pieces in a variety of national magazines, as did her brother Charles Howard Shinn. He later worked at the University of California Experimental Station for Dr. E.W. Hilgard and became one of the first chief rangers of the United States Forest Service. Milicent retired as editor to take up the first doctoral studies by a woman at the University of California at Berkeley, and she pioneered the study of child psychology. The Shinns' books are still in print.

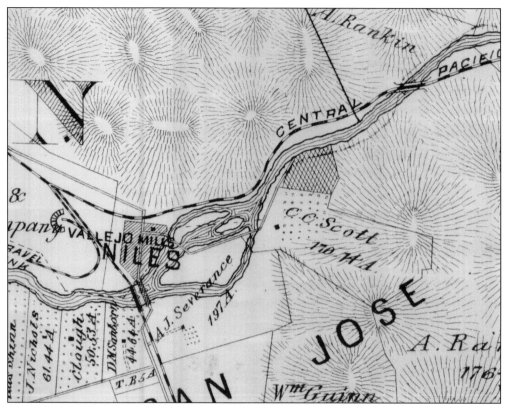

The 1878 Thompson and West *Official and Historical Atlas Map of Alameda County* shows the relationship between the 1869 Vallejo Mill town plat (hatched pattern), the main railroad way, the roundhouse, and various lines of the Central Pacific Railroad. Jonas Clark controlled the land north of Alameda Creek until 1884. The names of the many orchard and vineyard holdings on the south bank of the creek are familiar names in Niles; the large Scott vineyard on the terrace above Alameda Cañon is shown cross-hatched.

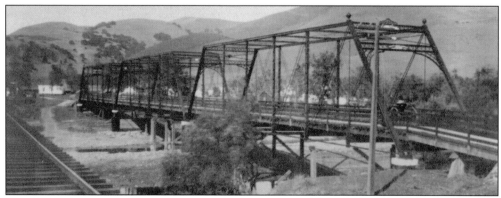

This 1895 photograph shows the wagon bridge crossing Alameda Creek that connected the town site with the more rural parts of Niles. Children crossed the bridge to Niles Grammar School and people traveled by horse and buggy to meet the train or do business in the new shops established on Front Street across from the Niles Station. As the town grew the name First Street became common usage. Only after incorporation of the City of Fremont in 1956 was the name Niles Boulevard commonly used.

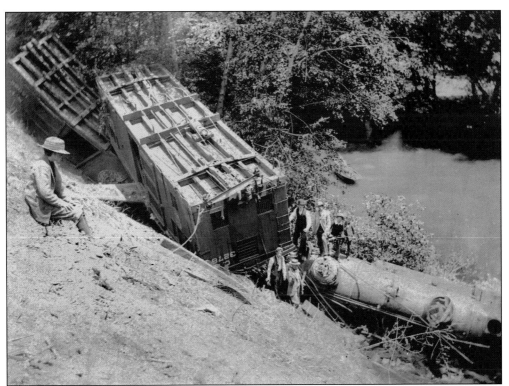

Boys and men in their Sunday clothes, bowler hats, and straw boaters explore the train wreck in Niles Canyon, midsummer in the early 1900s. As Niles became known as a picnic day-tripper destination around 1900, the name Niles Canyon replaced Alameda Cañon. This steam engine came to rest just above Alameda Creek; the cattle cars can be identified by the many vented openings and by the exit ramp where they have already been removed.

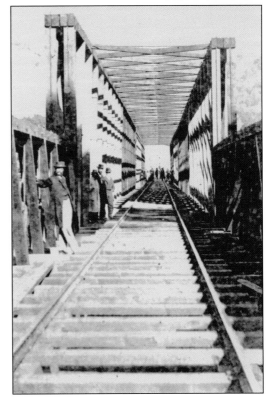

In 1868 the first railway was built adjacent to Vallejo Mills and another constructed from San Jose to intersect it in Alameda Cañon. In 1870 the San Jose Junction in the canyon was abandoned when that bridge washed out and this wooden railroad bridge was built close to Niles Station. Until Benicia began operation of a rail ferry in 1879, Alameda Cañon was an essential link on the overland route for the Central Pacific Railroad. Robert Louis Stevenson traveled this way on the journey described in the *Amateur Emigrant*.

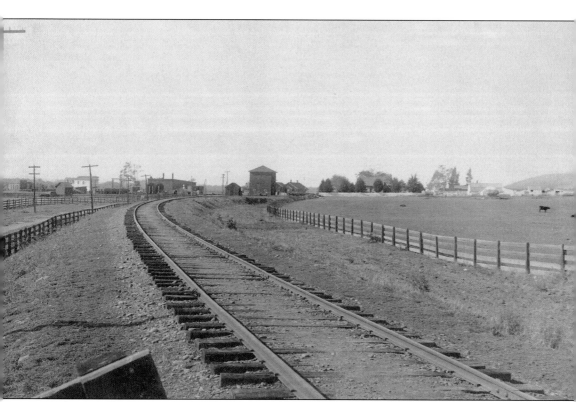

This view from Old Town looks toward the newly platted Town of Niles. Sulphur Springs Ranch with its fenced corrals sits to the right. Murphy Briscoe grocery is on the corner that would later become the site of the Ellsworth Building at I Street and Niles Boulevard. On the opposite corner is Easterday's Senate Bar, now the Fremont Bank. Judge Addison C. Niles (1832–1890) was a Central Pacific Railroad attorney and stockholder and the CPRR gave his name to the station here in 1870. He became a California Supreme Court justice (1871–1880) and was based in San Francisco. The Southern Pacific Railroad did not formally register the town plat for Niles, with its lettered and numbered grid streets, until after it took over the Central Pacific Railroad in 1884. The Niles Station area did not develop as a commercial district until the early 1890s, by which time Judge Niles had died.

FLOOD OF 1861

The roar of the water was something dreadful, it could be heard miles away . . . Everyone who was so unfortunate as to have a cellar had it full of water and mud. One lady had a cake in a stone jar at the time and she never found her jar. Perhaps it will be dug up sometime and they will think it the remains of some race long extinct. To watch the many things that floated down in that awful surging angry water as it swept through the valley on its errand of destruction. Large trees, chicken coops, hen's nests, lumber—anything you would find in a back door yard too numerous to mention.

The water was three feet deep on the Ellsworth, Sanborn, Clough and Nichols places as far as the eye could see there was nothing but water, and when the water fell there was nothing but soft mud and brush everywhere. There were no lives lost but it seemed only providence that saved us. But Vallejo Mills lost much of its beauty in the flood.

The people of Vallejo Mills in 1857 received their mail by way of Centreville until after the railroad was built. Then the name of the place changed to Niles and an express office was established in the old Scott store and William Snyder was appointed agent at a salary of $25.00 a month. After holding the office two years it was moved to the depot.

It was not until 1873 that Niles had a Post-office, it opening in November of that year. When the office was first established there were only two mails a day, one in the morning and one in the evening. The first salary was $12.00 per annum.

<div align="right">

—Handwritten accounts by Mrs. Snyder
Niles, 1904

</div>

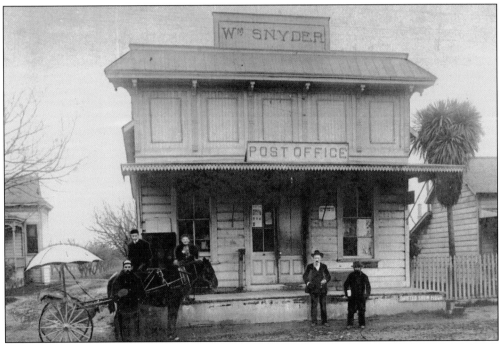

The William Snyder general store and post office relocated from Vallejo Street to Front Street in the new Niles town plat, and is pictured here in the 1890s.

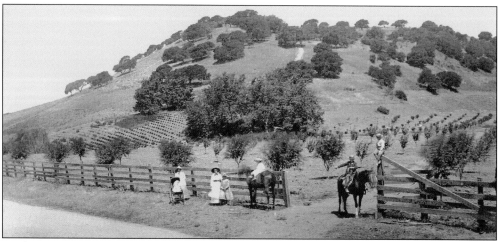

In this 1885 photograph 20,000 goblet-pruned grape vines are shown at three years of age. Harrison Mayhew was listed as a grape grower in the detailed surveys carried out by the state viticultural commission in 1891. Of his 66 acres of grapes, all of which were bearing by 1891, 25 were wine grapes, 25 table grapes, and 16 raisin grapes (Muscats). The wine grape varieties included 15 acres of Zinfandel, 5 of Malvoisie, and 5 of Cabernet Sauvignon. There were several grape vineyards in Niles in 1891, the largest of which was Edward Clark on the Scott terrace at the upper end of Canyon Heights. Most of these vineyardists grew Zinfandel grapes, and may well have sold to the Gallegos winery in Irvington for its claret production. By 1894 the grape production in Niles was 431 tons from 98 acres strung along the road to Mission San Jose, including Edward Clark who produced 2,000 gallons of wine right at his terrace vineyard.

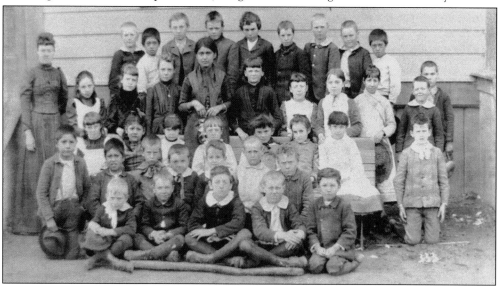

The names included on this roll call of Niles Grammar School in 1891 include Walter Baldwin, Alice Cantadine, Ralph Case, Stuart Chisholm, George Dickey, Mike Dickey, Eclesia Domenici, Frank Duarte, Carrie Ellsworth, George Harding, Alfred Higgins, Nellie Higgins, Florence Hudson, Alice Hudson, Hazel Jacobs, Harry Jacobus, Guy Jacobus, Leland Jacobus, Lila Jones, Nola Leymorr, Arthur Martenstein, Frank Matz, Joe Matz, Bessie Moore, Dan Murphy, Charlie Nichols, Frank Nichols, Joe Nichols, Rosie Nichols, Mike Palmer, Mary Perry, Hazel Thane, Harry Tyson, and Wayne Youngman.

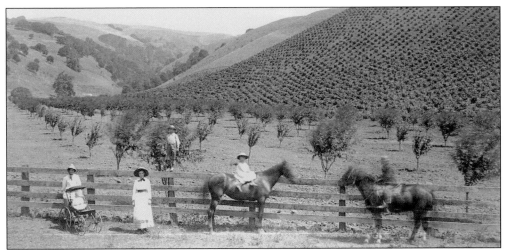

John C. Rock, manager and major investor in the California Nursery Company, grew a specimen vineyard to study the characteristics of 200 grape varieties. His vineyard included a full range of wine, table, and raisin grape varieties available from 1884 to 1894. These were grown on eight-foot spacing and would have been goblet pruned similar to those in this Mayhew photograph of the Sulphur Springs ranch. Rock also experimented with every type of rootstock combination, as well as the new grape varieties being developed in California.

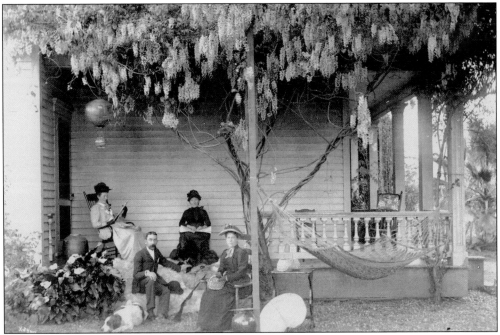

Here members of the Overacker family sit on their wisteria-covered porch in the 1890s. The Overacker farm has been home to the California Schools for the Blind and Deaf since 1980. A few years before 1860, John Conrad Naegle (Naile), a German vintner, was called away by Brigham Young to establish the Toquerville Winery in south Utah. His adobe was located on what became the Overacker farm in 1860. The first weddings, dances, and orchestral concerts in the Niles area were celebrated at the Naile adobe, which is commemorated by a monument at the intersection of Walnut Avenue and Cherry Lane.

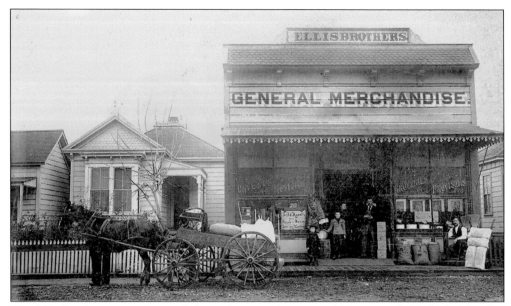

The Ellis Brothers opened one of the early general stores in Niles around 1890, shortly after Niles was platted. The raised platform out front made it easy for getting out of a buggy or unloading cartage. Elliston Winery on nearby Kilkare Road off Niles Canyon has historic links to Niles. It was designed and built in 1890 by the father of the Ellis Brothers, Forty-niner Henry Hiram Ellis, who was elected San Francisco's chief of police in 1875.

Minnie Snyder Chalmers, William Snyder's daughter, took over from her father as postmaster after her husband, Dr. Chalmers, died. She had the post office custom built for the second half of her term; that building is now at 37825 Niles Boulevard. This house with its gracious pair of palms (one still living) is the Snyder residence, part of the Smith Furnishings block today, behind 37835 Niles Boulevard.

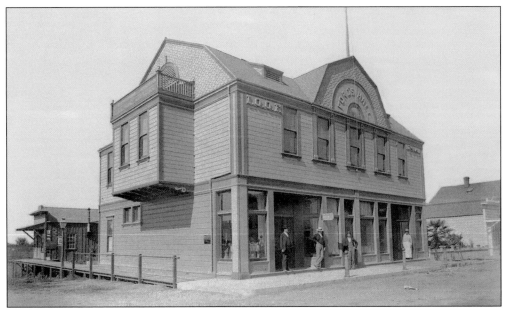

Ford's Hall, the subject of this 1895 photograph, was built as an International Order of Oddfellows (IOOF) meeting hall in 1895 at the corner of Front and J Streets (37965 Niles Boulevard). Sneden's Pharmacy was located on the left side of the ground floor. Rodgers Cobbleshop and the Niles Meat Market were also on the ground floor to the right, past the sign advertising the *Chronicle*. A stairway went up the middle to the meeting hall.

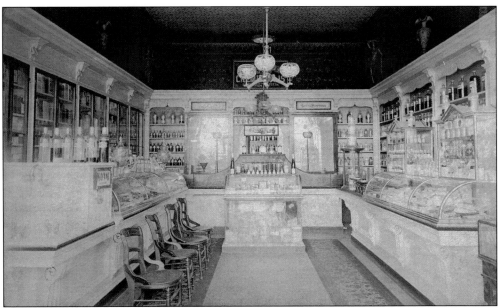

A traveling photographer recorded the interior of Sneden's Drugstore in 1898, complete with its elegant gas lamp fixture; Niles received electrical services in 1900. Signs in the drugstore included "toiletries, choice perfumes, for the complexion and teeth." Sneden's was still going strong in 1914 when it was advertising a wide array of patent medicines as well as "simple mixtures."

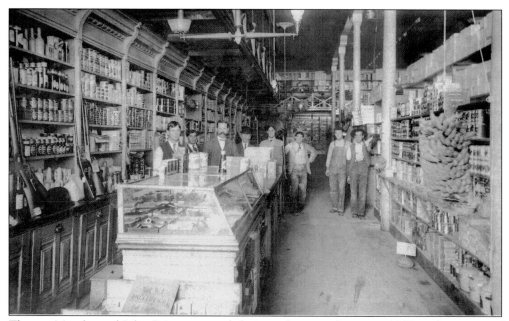

Thomas Murphy and John Briscoe opened their gas-lit general store in 1892 at the corner of I Street and Front Street (later to be known as the Billy Moore Café, followed by the Ellsworth Building at 37597 Niles Boulevard). To start the store Thomas Murphy left a milk delivery cart route in Mission San Jose where his Irish immigrant father ran a hotel. He later married his partner's daughter.

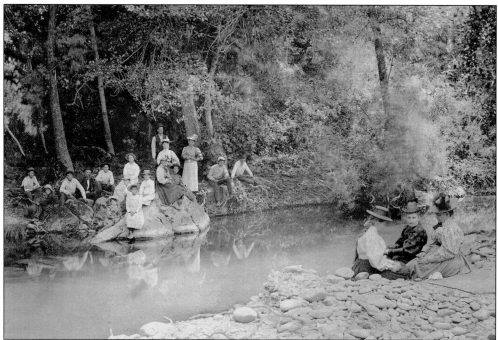

This picture shows what appears to have been a Washington College picnic in the mid-1870s. It was held at Stonybrook in Niles Canyon, where even in the hottest weather and driest years there would be pools of water late in the summer.

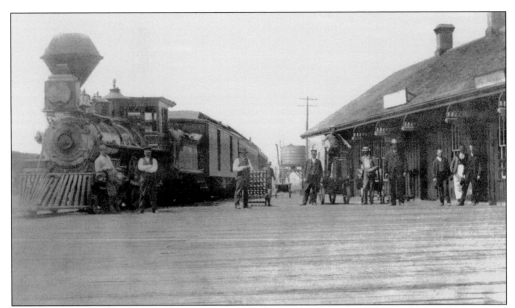

The George Fisher family was photographed here in 1876 at Niles Station where they ran the restaurant and hotel. George advertised in 1890 as operator of the restaurant and agent for the Sunset Telephone and Telegraph Company; his advertisement stated "Lunches put up to order and meals served on short notice." In 1897 he was proprietor of the Depot Restaurant and bar.

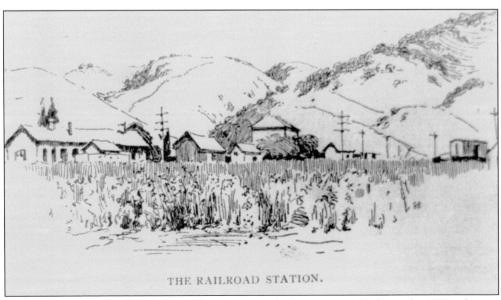

THE RAILROAD STATION.

To illustrate an article that Milicent Shinn wrote with descriptions of Niles in the 1880s, she was able to commission rising young artist Ernest Peixotto. His sketch of Niles Station, telegraph poles, and the familiar backdrop of hills comprised the view before Front Street developed. Peixotto went on to write and illustrate a series of books, such as *Romantic California*, idealizing architectural themes that were later taken up as Mission Revival.

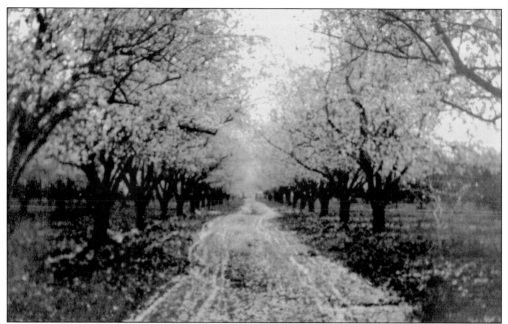

The White Way of Delight was made famous by writer L.M. Montgomery with *Anne of Green Gables* in 1900; this photograph shows that a "White Way of Delight" already existed in the Mayhew almond orchard at Niles. A blossom festival was held here in 1894.

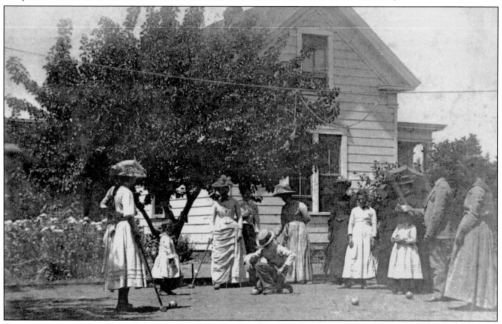

Croquet was played at the Thane-Tilden household in the 1890s, and Laura Thane stands at the far left ready to play while her brother Bart kneels. He grew up to graduate from the University of California at Berkeley as one of its champion football players of 1898 and one of its first mining engineering graduates. Bartlett Thane's engineering advances in hardrock mining and power supply in Alaska led to the town of Thane, now a suburb of Juneau, being named after him.

Two

A WESTERN TOWN
1894–1917

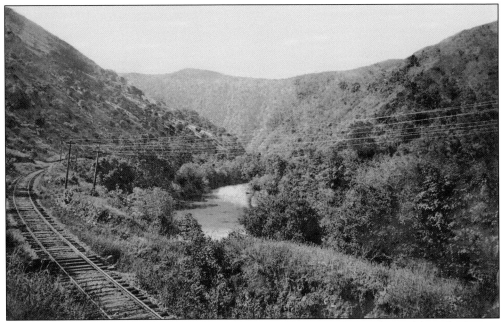

This c. 1900 photograph by Strong, depicts the Southern Pacific tracks in Alameda Cañon. (The second Western Pacific Railroad would not be constructed for another decade.) The dirt road through the canyon appears in the brush on the right side. (Courtesy Phil Holmes.)

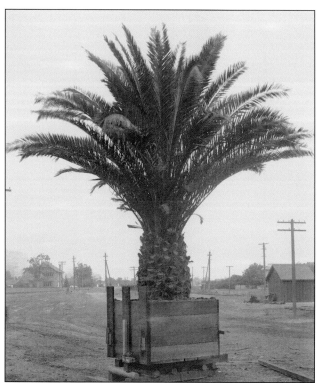

A boxed Canary Island palm from the California Nursery Company waits to be planted near the new Southern Pacific Railroad Station in Niles. The second Niles Grammar School can be seen in the far left background between the Niles Wye and Vallejo Street. In the near background, to the right, is a line cabin for railroad crews to store their tools.

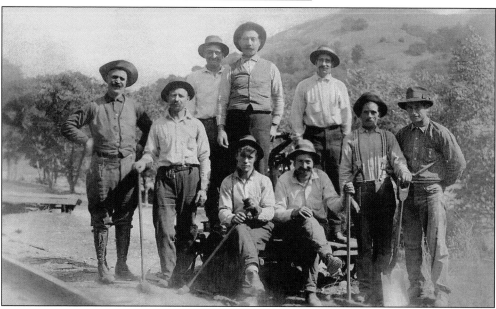

The census in the early 1900s lists Irish and Portuguese railroad workers as linemen. Until at least 1905 Jeremiah Daniel Lynch was the section boss for the crew that built and maintained tracks for Southern Pacific around Niles. Michael Houlihan emigrated from Ireland in 1854 and worked on the railroad into his seventies. His Queen Anne–style house may still be seen today at 37664 Second Street. This photo was in the collection of Mathew Vargas Jr. (Courtesy Laurie Manuel.)

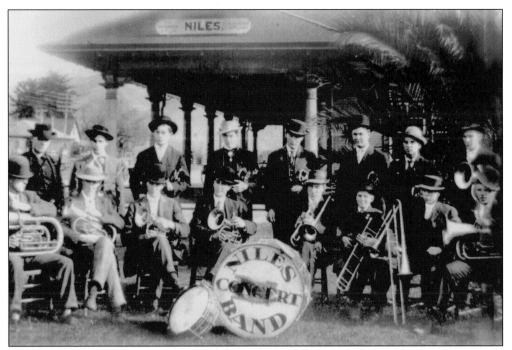

The 16-member Niles Concert Band of the early 1900s has the pillars and palms of the Niles Southern Pacific Railroad Station as a backdrop for its brass and percussion instruments; the band would take various forms during this decade. The 1901 station design chosen for Niles was the most elegant used on the SP line and, today, is the only example of its type still in existence. (Courtesy NESFM.)

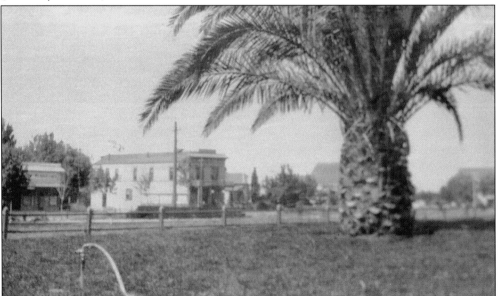

This photograph looks towards Front and I Streets, with the Senate Bar on the left and the Murphy Briscoe Grocery to the right. It also records the palms, irrigated lawn, and neat fencing around the new Niles railroad station. Several passenger trains arrived every day and, on the weekends, carried passengers to the picnic grounds and dance pavilions in Niles Canyon.

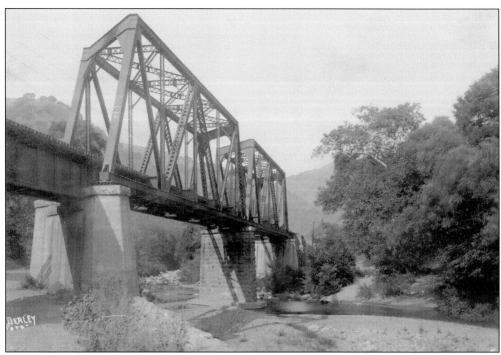

This Charles Allen Dealey photograph depicts the steel Dresser Bridge in Niles Canyon around 1914. It was built around the same time as the San Francisco earthquake in 1906. (Courtesy Dealey family.)

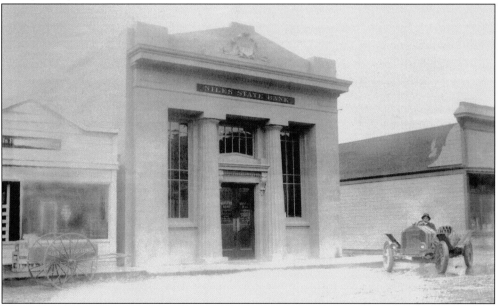

The Niles State Bank casts a somber face upon the latest in roadsters around 1911, shortly after the bank was built; it had been established in 1906. A Wells Fargo delivery dray is parked in front of the shop to the left. The bank frontage was remodeled in 1929 to become Scott's Shoes, and it was purchased in 1958 by the Walton family to become Side Street Antiques. The bank became the Bank of Alameda County, and moved to the corner of First and I Streets.

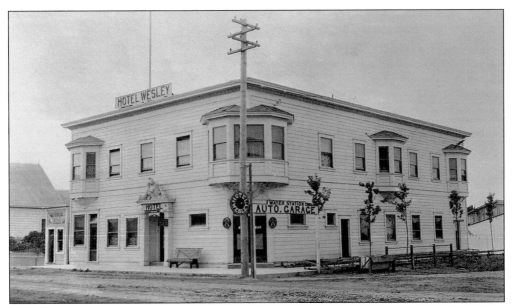

The Wesley Hotel, built in 1907 with 20 upstairs rooms, provided lodging for many of the cowboys and crew members of the Essanay Studios between 1912 and 1916. Many believe that Charlie Chaplin stayed here for at least one night. Behind and to the right is Wesley's Garage run by A.E. Champion and complete with a water station for keeping automobile radiators topped up.

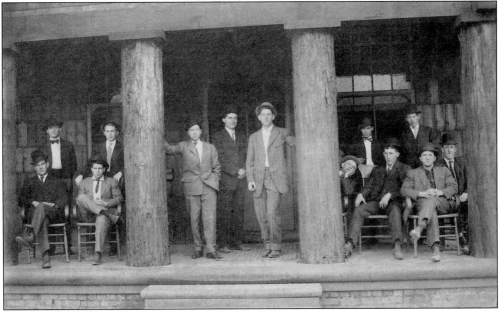

Recorded as a Niles saloon in the museum collections, this mystery building seems not to have been in Niles at all but a product of wishful thinking. The style of rustic log pillars on a concrete base was used at the 1909 Exposition in Seattle, the 1915 Panama-Pacific International Exposition in San Francisco, and for college clubhouses in the West. This picture appears to be the latter, and perhaps a scion of a Niles family is one of those lounging in a Jack London–style necktie.

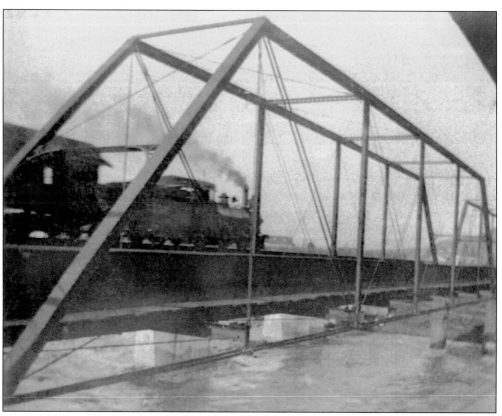

The steel railroad bridge crossing Alameda Creek at Niles was installed in 1873 and washed out in 1911. This early photograph with its curved edge is by Dr. Chalmers, who was an enthusiast of all new technology. He was the first owner of an electric buggy in Washington Township.

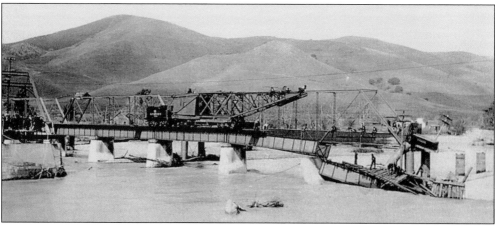

All the bridges across Alameda Creek suffered major damage during the floods of 1911, as seen in this photograph. Some bridge sections were hauled upstream and recycled in other bridgeworks; other parts surfaced years later during the hydraulic mining of the large gravel pits that now form Quarry Lakes Regional Recreation Area. The average rain for January in the Niles area is around 4 inches; in January 1911 over 13 inches fell in a short period of time. (Courtesy Harry Avila.)

34

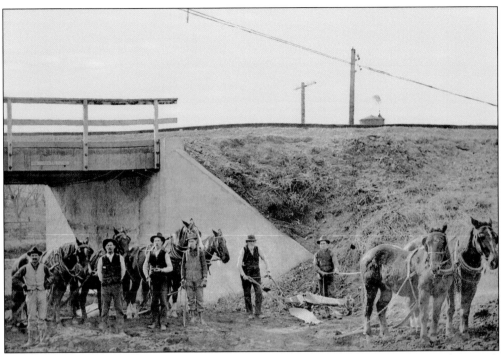

Niles first underpass, located approximately opposite the Ellsworth Fruit and Nut Packing yard, was built using both traditional road-work tools and the latest in concrete technology around the turn of the previous century. Later industrial uses of this creekside parcel included the Ames Pump Works, Victory Motors, Schuckl Cannery, Amchem, and Henckel. This underpass was replaced in 1937 by a larger one to the west that connected to the newly aligned Canyon Road.

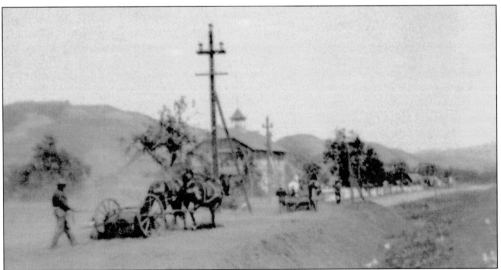

Horse-drawn road grading equipment is used to establish the grade to the railroad bridge after the 1911 floods. In the background is the Niles Grammar School, built in 1889. The first Niles Sunday school was started in the old Vallejo Mill warehouse in 1873. The first fundraiser was held not long afterwards; it was a subscription dance to raise funds for the one-room Niles School, built by 1875 west of the Vallejo Mills on land donated by the Central Pacific Railroad.

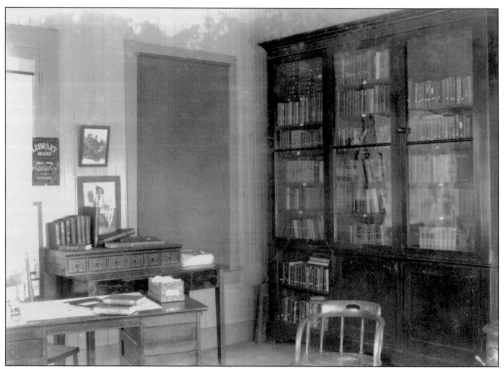

The Niles Library came into its own when the Southern Pacific provided the old train station in 1901, relocating it to the corner of I and Second Streets, a site that was later the home of the Niles Courthouse. To provide an evening activity for young people, the library was open after the dinner hour. Charles Shinn describes a model library in his *A Rural Handbook*, 1879:

> Briefly, the first needs of a library are a Webster's Unabridged Dictionary, a Cyclopedia, either Johnson's or Appleton's, and a large Atlas. . . . Next there might be an illustrated work on botany, one on geology, some of the Science primers, Tyndall's "Forms of Water," Faraday's "Chemistry of a Candle," "Orton's Zoology," "Newcomb's Astronomy," and similar books. This model library, however is not only to be a reference and authority, but also a sweet, refining influence. It must contain what a recent writer would call "the might and mirth of literature.

In 1878 Flora Apponyi Loughead's book, *Libraries of California*, was published by Bancroft. She divorced and married again in 1886 and appears to have met Milicent Shinn that year, if not earlier, yielding the opportunity to rent a cottage in the country at Niles for about four years. This cottage may have been on the Shinn Ranch or in the old town, as the town of Niles was not platted until 1888 and the California Nursery was just beginning.

Loughead's younger sons Malcolm and Allen were born in Niles in 1886 and 1889, respectively. By 1909 her eldest son, Victor Apponyi Loughead, had published (though only in his twenties) the early aviation classic, *Vehicles of the Air*, while Flora Loughead was actively publishing as well as running a vineyard near the future naval air base at Sunnyvale.

In 1915 the younger brothers took 600 passengers into the air in their Loughead Model G three-bay biplane for short floatplane joyrides at the Panama-Pacific International Exhibition. This funded the next stages of the development of flying boats, also known as hydroaeroplanes. By 1937, the name had changed to Lockheed, and successful plane design history had been made with pilots Charles Lindbergh and Amelia Earhart choosing it for their record-breaking exploits. By then Allen and Malcolm Loughead had moved on. During World War II Lockheed-Vega produced bombers and other military aircraft.

Sullivan's baseball field, west of the *Township Register* newspaper offices, was where Sullivan's Shamrocks played when the Niles Essanay Film Manufacturing Company first came to town. The Shamrocks were not well known for winning their games, whereas the Essanay teams were selected from among the best players in the San Francisco area. The newspaper building appears in the center of the photograph with its light-colored roof and false front.

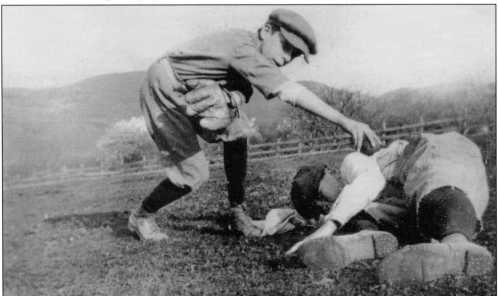

Charles B. "Chip" Overacker grew up on the family orchard on Mission Road (the section by Walnut Street is now called Overacker Road). Niles Canyon appears behind this baseball field, which is likely to be the Sullivan Field near the present-day Sullivan Underpass. Baseball came to California with the Gold Rush and has thrived ever since; this is one of the earliest Niles baseball photographs, taken around 1910. (Courtesy Overacker Collection, MLH.)

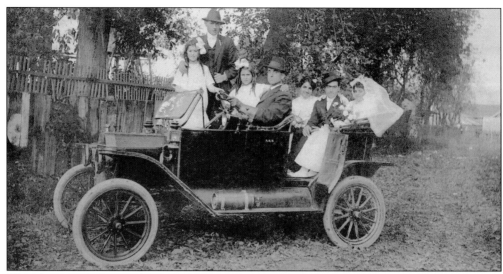

This photograph depicts the November 19, 1914 wedding day of Mathew Vargas Jr. and Annie Joseph, with witnesses Rose and Victor Dias, on their "runabout" journey back from St. Joseph Church in Mission San Jose. Corpus Christi Church built an American Gothic–style building in 1892 but did not become its own parish until 1914. A larger church was built next door to it on Second Street in 1957. The old church was demolished when the present parish center was constructed in 1969. (Courtesy Laurie Manuel.)

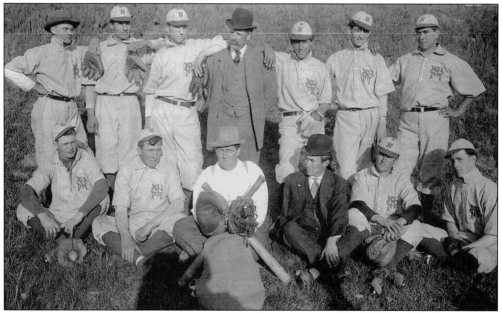

The Niles baseball team is pictured in 1911 with belted and buttoned-up club uniforms, a new raised rail bed behind them, and the shadow of the photographer in the foreground. Early on in Niles, baseball could be played at both Mayhew's field opposite the station and on Sullivan's field where the Sullivan underpass is now located. From left to right are (front row) Dan Greenwood, Dan Baldwin, Frank "Fat" Rose, George Rose, James McCray, and Lester Duffey; (back row) Joe Rose, Dean Preston, George Medeiros, Johnny Barnard, Bert Silvera, George Faber, and Walter Richards. (Courtesy NESFM.)

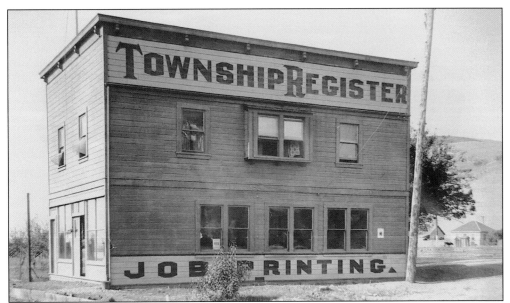

The Township Register was a landmark building at the end of Front Street, near where Niles Electric is today. It actually has a false front and side; from Sullivan's baseball field one could see the peaked roof. The company produced a weekly paper every Wednesday for the township. Few copies now exist and are greatly valued for the information of the day that they recorded.

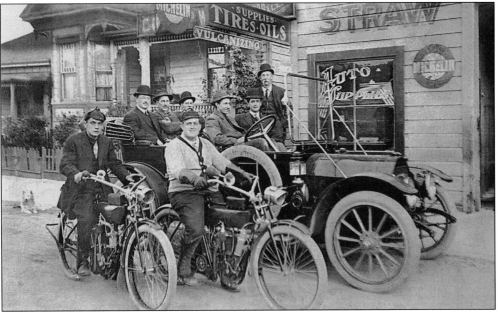

The men of the Rose family and their friends are photographed with their Indian motorcycles in 1911 in front of the Rose Livery Stable and the 1895 Rose home on Front Street, just east of Joe's Corner. By 1915 the Rose brothers had expanded the stables into a Ford dealership and garage; the house had been moved next to the Niles Jail. In this photo, from left to right, are (front seat) Ed Rose, George Rose, and Henry Youngman (standing); (back seat) John Parry, Charles McKeown, Joe Gomes, and Frank Rose. On bikes are John Parry (left) and Frank "Fat" Rose. (Courtesy Jack Parry.)

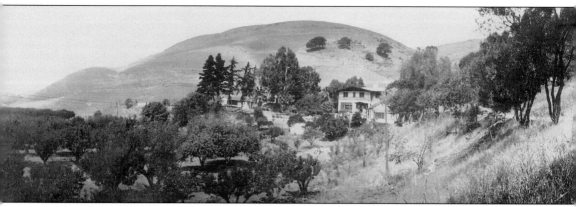

The Chittendens purchased this parcel of over 80 acres just west of the Sulphur Springs ranch in 1884 and built the large house on the hill in the 1890s. They delivered milk locally and grew every kind of fruit in its orchards; the prune orchard is where Duarte Avenue is today. The basement was finished off in 1902 with guestrooms and a bicycle room. The Belvoir became popular as a summer getaway. The Hotel Belvoir was the first home in Niles for the Essanay film company, hosting many of its employees between April and August 1912 when the first company bungalows were being constructed. The front porch and upstairs of the Belvoir were remodeled in 1913 after some fire damage. Today it is called the Belvoir Springs Hotel, and the freshwater springs are still flowing. (Courtesy Dealey family.)

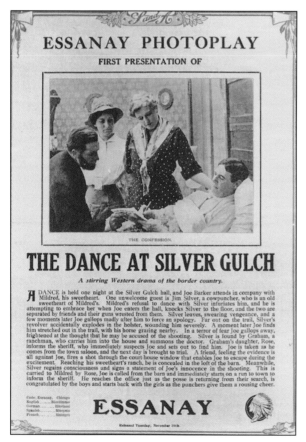

Twenty-four-year-old Essanay cameraman Jess Robbins discovered Niles in March of 1912, and by the end of the month the Western Essanay outfit had relocated there—stagecoach, horses, and all. The Champion barn was leased for a year and set up right away with the portable set. *The Dance at Silver Gulch* was filmed in Niles and released on November 19, 1912; by this date over 35 single-reel movies had already been filmed in Niles and released.

Bessie Sankey began as an actress in her native Oakland in 1907 when she was 16 and with Essanay at Niles when she was 21. During the time she spent in Niles, from November 1912 to July 1913, she roomed with Josephine Rector and starred in at least 20 Westerns, mostly Broncho Billy single-reelers opposite owner and star G.M. Anderson, as well as in some films directed by Arthur Mackley and Jess Robbins. This promotional photograph also includes a handwritten note from her to Josephine Rector.

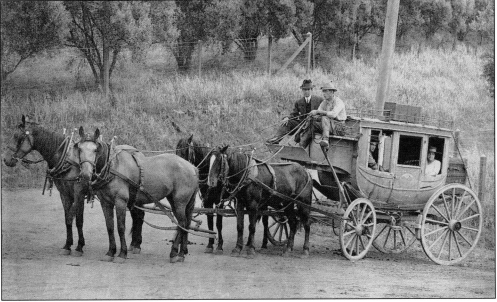

In 1912, filming in Niles was six days a week, with the company assembling at the barn and getting horses ready for that day's exploits in Niles Canyon and in Niles itself. This photograph is similar to what David Kiehn describes in his 2003 book *Broncho Billy and the Essanay Film Company*—a morning procession along Front Street being led by Anderson's Thomas Flyer and the sets on a dray wagon with actors, actresses, and cowboys mounted on horseback and the stagecoach with its team of horses. (Courtesy NESFM.)

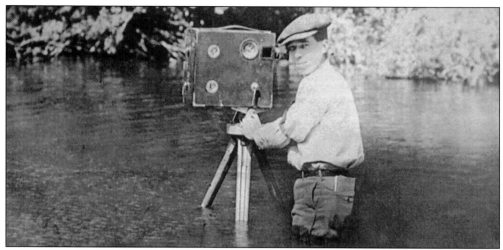

Usually the camera captures the landscape, but here the reverse is true. Lead Essanay cameraman Jess Robbins is pictured in Alameda Creek while operating his Bell and Howell film camera. Power and speed control were delivered by hand cranking a rotary lever on the side of the camera box, which held up to 200 feet of nitrocellulose film.

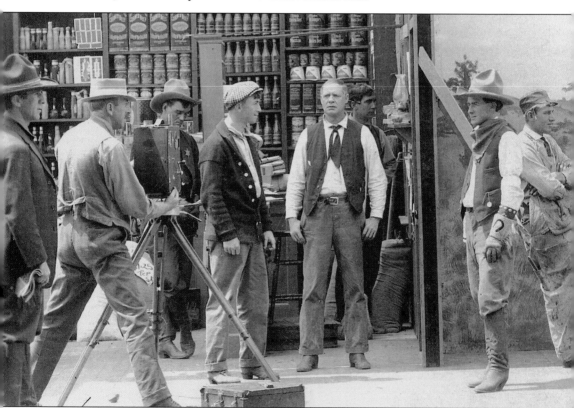

Days of the Pony Express was directed and apparently produced by Arthur Mackley, and was released in September 1913. This photograph shows the new glass-roof studios at Niles in use, with scenes underway on adjacent sets at the same time. The drama revolves around a postmaster's daughter, her pony express boyfriend, outlaws, and being saved by a telescope.

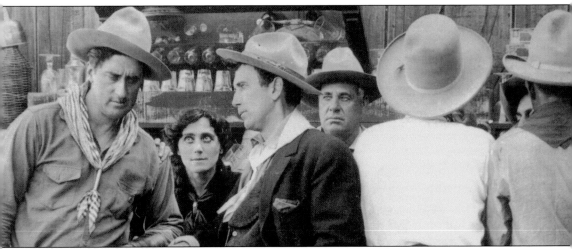

Essanay film number 00171, *A Borrowed Identity*, was released in October 1913; double-reelers were starting to be released by Essanay around this date. Essanay began film numbering in March 1913 with *The Influence on Broncho Billy* as number 00100. Pictured, from left to right, are True Boardman, Evelyn Selbie, Lee Willard, Harry Todd, and two unknown individuals.

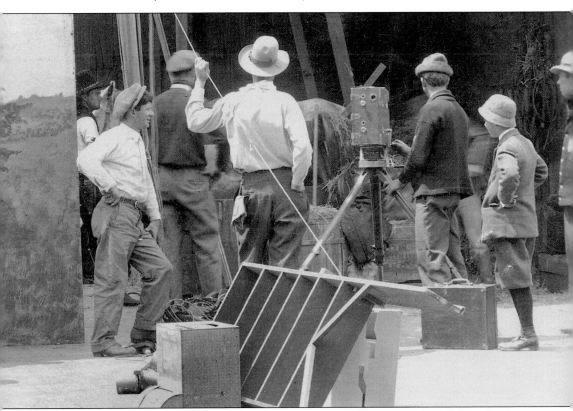

Pictured, from left to right, are Carl Stockdale, Arthur Mackley (cameraman), Bill Cato, Spider Roach, Harry Todd, Lee Willard, Jack Roberts, Lawrence Abrott (leaning), unknown, Stanley Sargent, Frank Dolan, unknown, Jess Morgan (cameraman), unknown, and Jess Robbins.

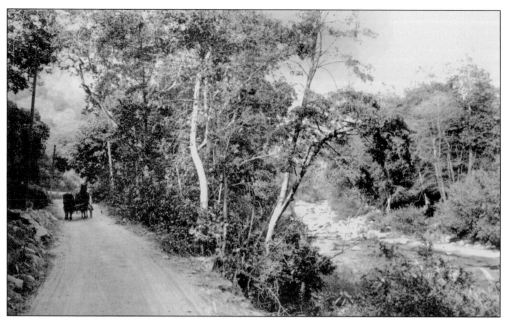

Essanay stills were taken by San Francisco professional photographer Charles Allen Dealey from 1913 onwards, about the time the numbering system was instituted. He made some of the first commercial landscape photographs in Niles Canyon, labeling them on the negative with his studio name, Dealey Foto. In this photograph, he captures an image of a horse and buggy in Niles Canyon emerging between the white and black trunked trees. (Courtesy Dealey family.)

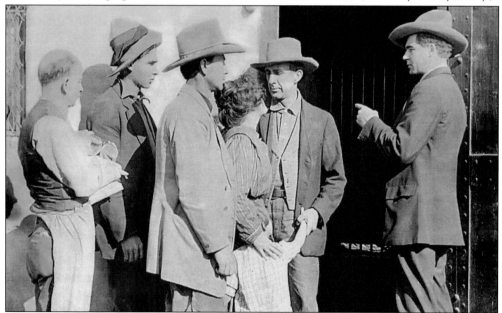

This street scene for *The Atonement* was filmed in front of the Niles Jail on Second Street in early 1914. It is the story of a sheriff unjustly accused of a crime because of something in his past. The working title of the film was *The Heritage of Evil* and it was released on March 26, 1914. Pictured, from left to right, are Jerome Anderson, Tom Crizer, Jack Wood, Reina Valdez, an unknown girl, Carl Stockdale, and Pat Rooney. (Courtesy Richard Crizer.)

Charles Allen Dealey assembled this promotional photograph in 1914, giving it the title *Margaret Joslin, Herself as Sophie Clutts*, promoting the star of the developing Snakeville Comedies being produced at the western Essanay Studios. Margaret Joslin was married to Harry Todd, another Snakeville star known as "Mustang Pete." They appeared in numerous Essanay westerns together between 1910 and 1916.

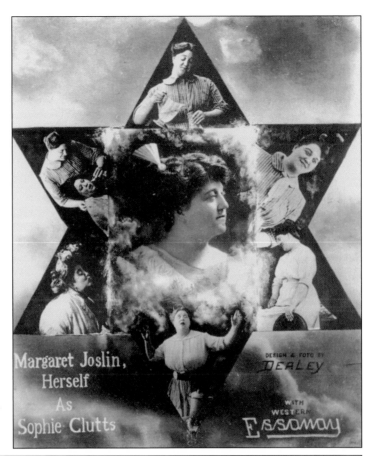

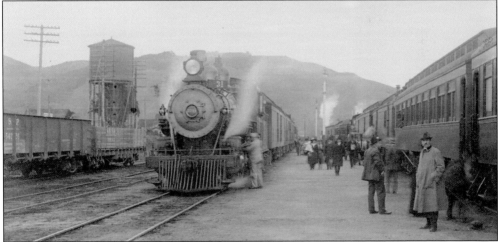

Scottish actor Arthur Mackley joined Essanay in 1910; Dealey photographed his tweed-coated departure from Niles in May 1913. All of the Essanay westerns with "Sheriff" in the title are Mackley's. He went on to direct for Reliance-Majestic in its new studios on Sunset Boulevard. Though no one knew it at the time, this was the peak period for use of passenger trains. The large water tank on the left was elevated around 1912 to supply steam trains and replaced the former square tank. (Courtesy Dealey family.)

Charles Allen Dealey himself was photographed here in 1915 at the Essanay Studios. He acted in small parts in some of the Essanay films in 1915, including some with Charlie Chaplin and in G.M. Anderson's last Niles film, *The Man in Him*. The collection of Dealey photographs on these pages reveals his eye for iconic glamour in both the natural setting and on the film set. (Courtesy Dealey family.)

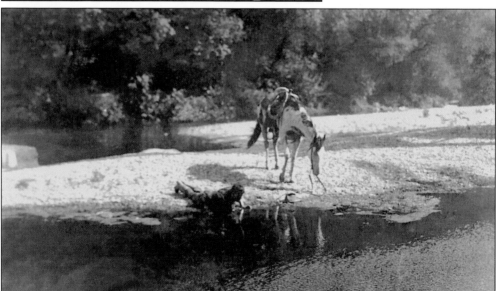

Dealey catches the light on the gravel bars in Alameda Creek, along with Bill Cato and his horse Pinto getting a drink. David Kiehn describes Bill Cato as the boss cowboy for the Essanay Company, as well as being Broncho Billy's stunt double. Cato's background was the real thing, as he became a champion broncobuster in his home state of Wyoming. His wife, Florence Perkes, was also hired for her horse-riding skills; they married while working at Niles and stayed with Essanay from 1912 to 1916. (Courtesy Dealey family.)

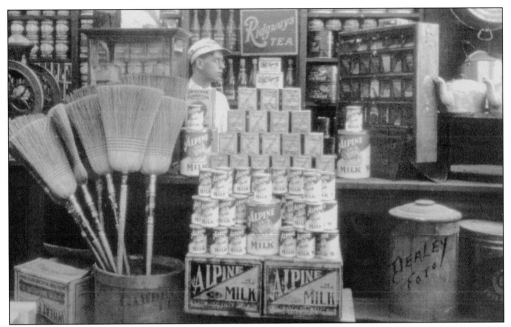

This Dealey photograph captures son L. Allen Dealey on the grocery store set put together by Kite Robinson. Apparently the cans were empty and glued together to create the display pyramids and the "can units" on the shelves. The Dealey Foto moniker was disguised as a label on the pickle crock. (Courtesy Dealey family.)

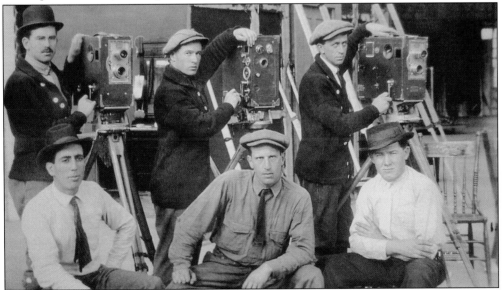

Essanay cameramen and assistants are pictured here at the other end of the camera lens at the Niles Studios in 1914, with the assistant cameramen in the front row. It was a skunk works, to use a term later taken up by Lockheed. When the United States entered World War I on April 6, 1917, most of the lead personages from Niles were either involved in theater in San Francisco or movies in Hollywood. Many went on to have careers that spanned several decades in the film industry. From left to right are (front row) Howard West, Mervyn Breslaur, and Martin Killilay; (back row) Ira Morgan, Rollie Totheroh, and Harris Ensign. (Courtesy NESFM.)

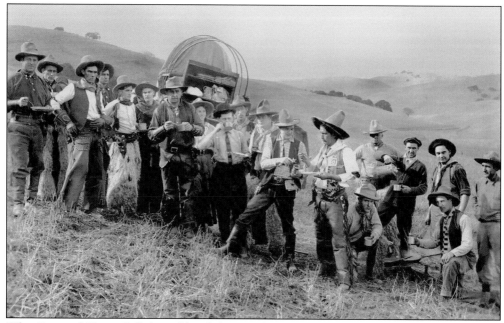

When Love and Honor Called was filmed above Niles at a hill location tucked into either Vargas Plateau or Walpert Ridge, apparently known as Bundy's ranch at the time. This still was taken around the chuck wagon on November 3, 1914, and labeled "the S&A Moving Picture Co., Niles Cal." This three-reeler was directed by G.M. Anderson. Pictured, from left to right, are G.M. Anderson, William Coleman Elam, Tom Crizer, Bill Cato, Jack Roberts, Leo West, Fritz Wintermeier, Gertrude Cassidy, Frank Dolan, Joe Cassidy, Darrell Wittenmyer, Harry Todd, Lee Willard, unknown, Martin Killilay, Robert Burroughs, Ernest Van Pelt, Mervyn Breslaur, and Warren Sawyer. (Courtesy David Kiehn.)

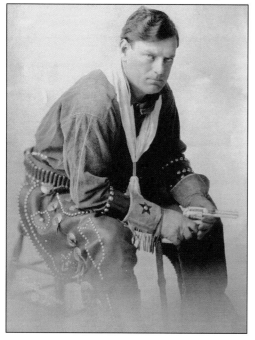

This is a promotional photograph of G.M. Anderson as pioneer film star Broncho Billy with his trademark studded chaps. Under Anderson's leadership out west, the Essanay Film Manufacturing Company pioneered innovations in film-making. The two-reeler and longer, more detailed plots for movies were developed by him. These were the first westerns with a believable hero, as well as the first two-reeler Snakeville Comedies. The transformation in Niles Canyon of Charlie Chaplin's early tramp into a character with depth, love, and real pathos (to become a worldwide phenomenon) took place as part of the creative environment promoted by the Essanay Studios at Niles.

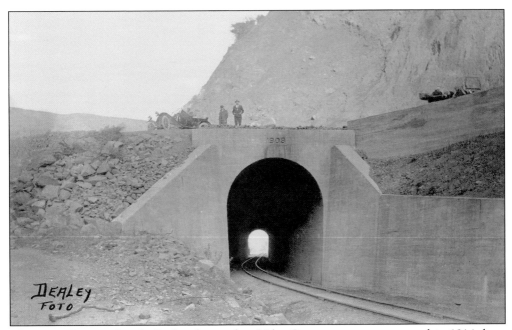

The 1909 Western Pacific Railroad tunnel in Niles Canyon was reconstructed in 1914; here Charles Allen Dealey transforms the white concrete forms and Romanesque arch in Niles Canyon into a classic image with a play on black and white shapes. (Courtesy Dealey family.)

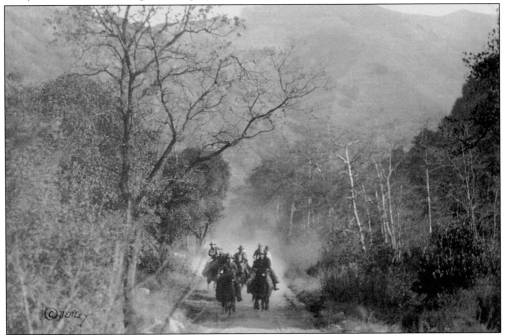

David Kiehn described exactly this scene shown in a Dealey photograph taken around 1915. "Shooting toward the sun and exposing for the shadows was another trick, particularly effective with a posse kicking up dust behind it as the cowboys rode toward the camera." The print is so detailed that G.M. Anderson can be recognized leading the posse down Niles canyon. (Courtesy Dealey family.)

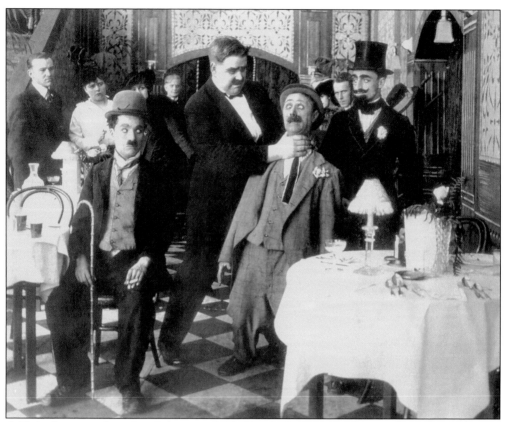

A *Night Out* was released on February 15, 1915 and was Chaplin's first movie at Niles. It was a two-reeler filmed in a café set at the Niles Essanay Studios. The street scenes in Oakland were taken in front of a real café. In this photograph, taken by L. Allen Dealey, are, from left to right, Eddie Fries, Hazel Applegate, Charles Chaplin, unidentified, Charles Allen Dealey (restaurant manager), Bud Jamison (hot-tempered waiter), Ben Turpin, unidentified, William Coleman Elam, and Leo White (the Count). (Courtesy Dealey family.)

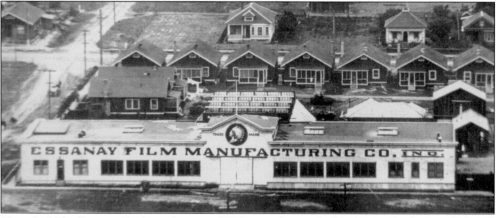

Here the Niles Essanay Studio is shown in 1913, complete with the glass studio (center, behind) and a small film lot (right, behind). An entire group of bungalows and concrete stable are just outside the photograph on the far right.

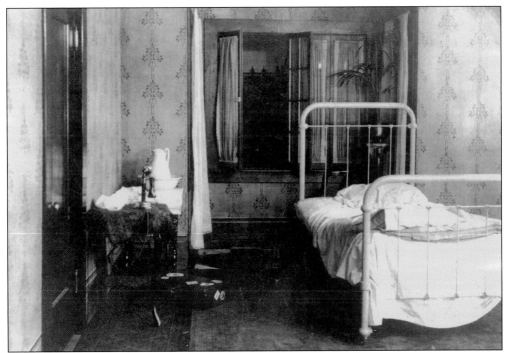

Charlie Chaplin ordered this set for a bedroom scene at Niles Essanay Studios for the 1915 movie, *A Night Out*. Set components were recycled and assembled in new combinations for each movie.

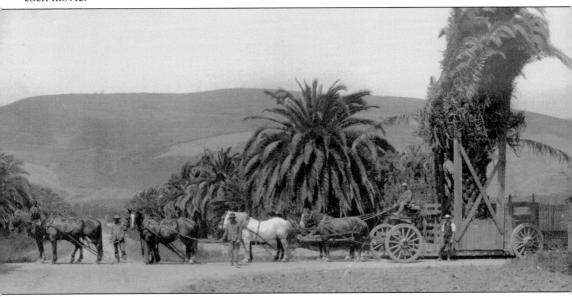

Here a Canary Island palm is being transported by a team of eight horses to the station at Niles for a rail journey to San Francisco in 1915. While *The Jitney Elopement* was being filmed in Golden Gate Park in the spring of 1915, director and star Charlie Chaplin and other Essanay stars attended the events of the Panama-Pacific International Exposition (PPIE). The great lush palms that made the Palm Court and other avenues at the PPIE so distinctive were supplied by the California Nursery Company at Niles.

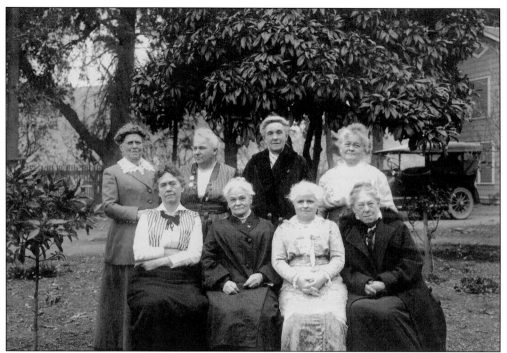

Niles ladies pose in front of the Tyson house prior to a trip to "the city" around 1915; they may well have been on their way to Niles Day at the Panama-Pacific International Exposition. This was held during the peak of almond blossom season, when loads of blossoms were brought to decorate the exhibits. The women's names are listed on the back of the photograph. They are, from left to right, (front row) Mrs. William H. Tyson, Mrs. Fisher's friend, Mrs. Fisher, and Mrs. James R. Clough; (back row) Mrs. Henry Goodrich Ellsworth, Mrs. George H. Hudson, Mrs. Joseph Tyson, and Mrs. Joseph Eiley Thane.

The Curtiss Jennies lined up on the Oakland airfield were bought as barnstormers after World War I by people such as Lawrence Bunting, who crashed one in a hayfield just north of Niles. The field burned and his mother had to pay for the lost crop. (Courtesy Jill M. Singleton.)

The Poppy Nymph was originally carved by Jo Mora to exhibit at the PPIE with five other pieces. He was invited to serve on the International Jury of Awards and helped select those who won them. Purchased by Niles's first millionaire, William H. Ford, it was deeded to John Evans Kimber of Niles in 1956 and in turn deeded by him to the Niles Library in 1970. In November 2003 the piece traveled back to Monterey as the primary example of Jo Mora's sculptural work for the Monterey Maritime Museum exhibit "From the Studio: Jo Mora." The sculpture returned in March 2004 to her home in Niles. (Courtesy Mark Shelton.)

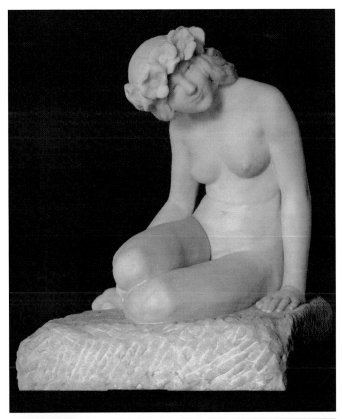

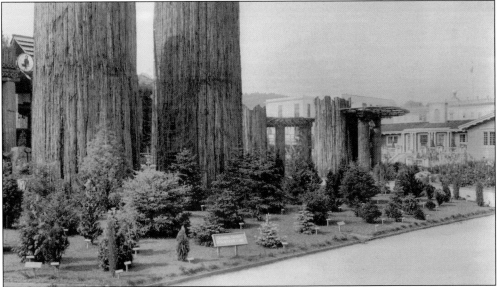

The California Nursery Company won a gold medal for its conifer exhibit at the PPIE. Louis C. Mullgardt, designer of the "Court of Ages" and other features of the fair, was also responsible for the "House of Redwood" model bungalow seen to the far right. The massively scaled trunks in the display were assembled on site and do not extend much further than the photographed size. (Photo by Cardinelli and Vincent.)

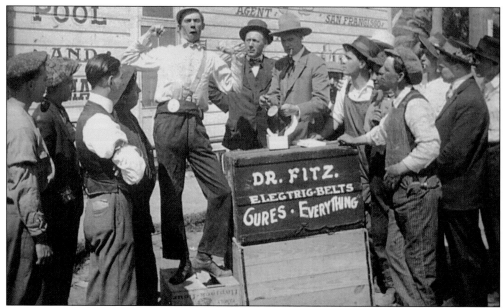

This Essanay scene for *Sophie and the Faker* was filmed on J Street in early 1915 in front of the dairy store and released in May of that year. Victor Potel played the role of the electric belt salesman. The director was Roy Clements, who lived in Essanay bungalow #8, now at 249 School Street. Pictured, from left to right, are two unidentified individuals, Ernest Salter, unidentified, Victor Potel, unidentified, Harry Todd, Frank Sund, unidentified, Joe Cassidy, unidentified, Ben Murphy, and an unidentified individual. (Courtesy Harry Avila.)

Painted canvas backdrops, faux pillars, and seedling palms (easily found in Niles) create the setting for *Broncho Billy's Love Affair*, filmed at the Niles Essanay Studios in 1915. The Essanay crew members were hired for their various talents such as baseball (Fries), horsemanship (the Catos), and camera skills (Robbins), but they could also project glamour. Pictured, from left to right, are Eddie Fries, Bill Cato, Florence Cato, Margie Rieger, and Jess Robbins.

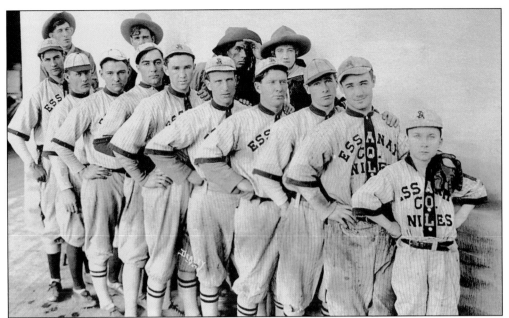

The Niles Essanay baseball team appear in their stylish uniforms of 1915. These uniforms, with letters down the front button edge in a contrasting color, were popular only in that year. The belt channel design had yet to be invented. Pictured, from left to right, are (front row) Kite Robinson, Martin Killilay, Eddie Fries, Duke Denterle, Robert Burroughs, Mervyn Breslaur, Frank Dolan, Rollie Totheroh, Earl Esola, and Dewey McCarthy; (back row) Joe Cassidy, Bill Cato, Tom Crizer, and Florence Cato. (Courtesy Harry Avila.)

The two-reeler *Her Lesson* was finished by director G.M. Anderson on December 22, 1915, and released January 4, 1916. He played a wealthy capitalist in the film. The set includes local bricks, an arts and crafts–style table lamp, and Persian carpets layered with a polar bear rug. The set design was not assigned to a specialist at this early date, so it is not known if this reflected Anderson's personal taste.

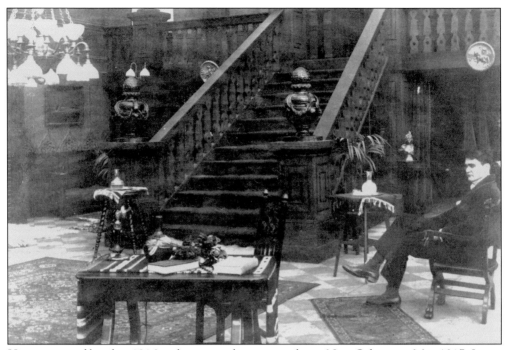

Humanity was filmed in 1916 and premiered as a six-reeler in New Orleans in May 1917. It was G.M. Anderson's last film appearance as Broncho Billy. It was photographed by Rollie Totheroh with a Bell & Howell 2709 camera. Rodney Hildebrand, shown here on the set, continued as a film actor into the 1930s. The set flooring and the lighting fixtures can be recognized as pieces of other Niles Essanay film sets.

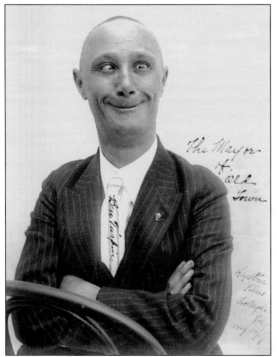

Vaudeville favorite Ben Turpin married actress Carrie Lemieux of Quebec in 1907 and was discovered by G.M. Anderson the same year; Ben became Essanay's first actor. The couple came to Niles with Charlie Chaplin in early 1915, staying after Chaplin left, until the Niles studio closed in 1916. Ben Turpin was the lead in the series of Snakeville Comedies directed by Wallace Beery. Ben and Carrie were much loved members of the company and in town. They made their home in the Essanay bungalow at 37354 Second Street. As he wrote here to a friend in Niles in 1917, Ben was nicknamed "the mayor of Old Town."

The excitement of the Panama-Pacific International Exposition ended on December 4, 1915. The filming at Essanay Studios at Niles was halted on February 16, 1916, with a stop work telegram from Chicago. Both enjoyed a four-year life in the Bay Area. But life in Niles continued—the ball games went on, even if there were no more highly paid stars to play at Sullivan's field. (Courtesy Overacker Collection, MLH.)

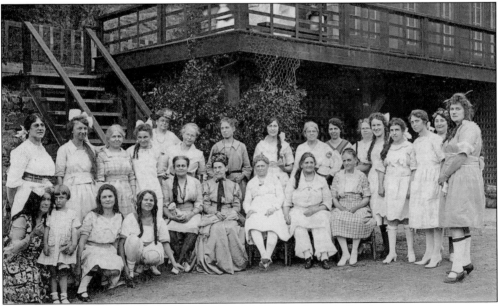

The various churches and civic groups of Niles undertook local concerts, drama, and Chautauqua-style performances regularly. These Niles ladies held a theme party in Niles Canyon; the shingled club house may be Kilkare Woods. On the balcony (but not visible) are Mary Gregory and Mrs. Bunting. From left to right are (front row) Mrs. Jacobus, two unidentified ladies, Mary Bernard Jacobus, Mrs. Hatch, unidentified, Mrs. Ellsworth Jr., Mrs. Gregory, and Mrs. William Snyder; (back row) Mrs. William Ford, Mrs. Jones, Mrs. Walpert, Mrs. Ned Ellsworth, Mrs. Bunting, three unidentified ladies, Mrs. Chittenden, Mrs. George Chalmers, two unidentified ladies, Mrs. Martenstein, Mrs. Green, Mrs. Donovan, and Mrs. Trask.

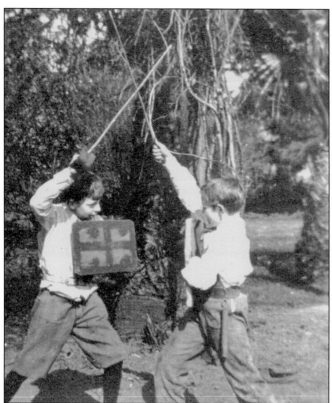

Niles musketeers Charles B. Overacker and a friend take on swordfighting with handmade shields and swords around 1910. Overacker's graduating description in his *Senior Record* for the Washington Union High School Class of 1917 (for which he was editor) states his nickname as "Chip," his appearance as "dwarf," his favorite occupation as "playing banjo," his favorite song as "Oh! Glorious (Victory)," his favorite expression as "I suppose I did that," his ambition to be "a second Jess Willard" (heavyweight boxer), and his favorite study as "fighting." He grew up to be a career fighter pilot.

The Alameda Creek flood of 1917 greatly eroded the soil of the Italian market gardens on the south banks of the creek. The Broncho Billy Staging Area for the Alameda Creek Regional Trail is in this location today on the Old Canyon Road. In the far distance the smoke of the California Pressed Brick Company at Vallejo's adobe brickmaking site can be seen. To the right is the part of Ellsworth Island that became Elderberry Park and later a mobile home park.

Three

ONE-SIDED RAILROAD TOWN
1917–1941

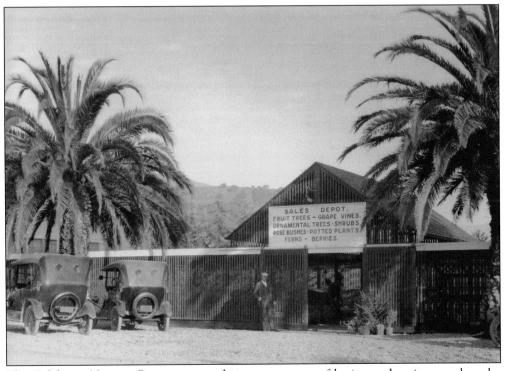

The California Nursery Company moved into a new type of business when it opened a sales depot next to the railroad track at Nursery Avenue. In 1917 the nursery corporation was acquired by the Roeding family from the William Landers estate. Roeding Sr. then took the well-known California Nursery name as an umbrella for all his existing nursery operations. This was the beginning of a nursery brand name and the first chain of retail garden stores in Northern California.

Gabriel Moulin came to the California Nursery Company grounds at Niles to photograph for George C. Roeding Sr. in the late 1920s. In the middle distance to the right is the 1907 President's House; in the far distance to the left are the redwood packing sheds, greenhouses, and massive lath houses. Photographer Gabriel Moulin would have been standing by the railroad tracks looking south at this time, but Niles-Alvarado Road did not cut through to Niles until around 1930.

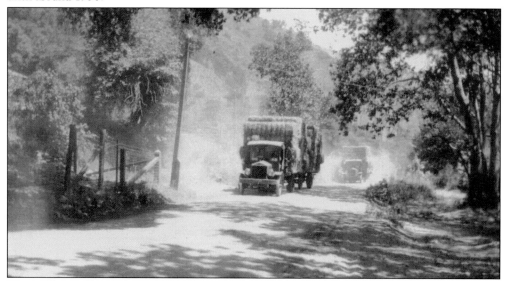

The trucking of hay bales was a regular sight in Niles Canyon and on the roads around Niles in the 1920s, as was kicking up dust in the dry season. One might be able to own a car or truck, but farmers also found it efficient to keep some horses at work for many decades yet. This photographer caught the same backlit conditions that interested the Essanay film makers in some of their most famous canyon scenes.

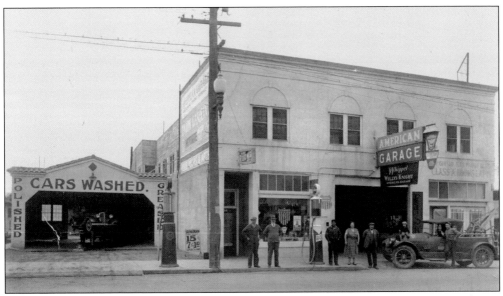

Salvador and Egizza Di Guilio started the American Garage and Auto Supply at G and First Streets in 1925, and Salvador's son Louis took over in 1926. This photograph was taken in 1931 when the price of gas on the sign read "15 cents per gallon, 7 gallons per dollar." In 1940 a new business, Di Guilio Furniture, was announced at "751 Main St., Niles, Between the American Garage and Florence Restaurant." The telephone number was Niles 67. Pictured, from left to right, are Ed Leal, Joe Nascimento, Tino Arias, Egizza Di Guilio, Salvatore Di Guilio, child Edward Leal Jr., and Louis Di Guilio.

This picture of Ben and Carrie Turpin was one of a series taken in Los Angeles in 1924 that they sent to Niles friends. Here they share their delight in their new Willys Knight sedan. One of the Knight ads that year promoted the cars as "Happiness, and lots of it." The American Garage in Niles advertised cars by the Willys Knight Company.

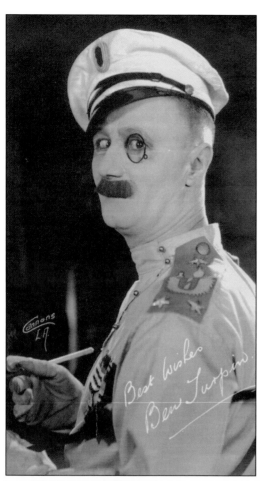

Ben Turpin played Rodney St. Clair in *Three Foolish Weeks* in 1924, a parody of *Foolish Wives* and a spoof of Erich von Stroheim. In the late 1920s he wrote a letter to Mrs. George Sladek that was published in the *Township Register*:

Now to talk about dear old Niles. I just don't remember what year I was in Niles, tho I recall the first time I came with Essanay, coming there with Charlie Chaplin and Broncho Billy (G.M. Anderson). I shall never forget the day I arrived. Went to work with Charlie in a picture titled "His Night Out". The next one was "The Champion". I stayed in Niles about a year and a half and made many friends, among whom was Judge Richmond, Mr. Murphy the grocery man, the Rose Bros. who had the Ford agency and Mr. F.J. Cesari. When I arrived in Niles, Mr. and Mrs. Harry Todd and Vic Potel were making slapstick pictures called "Snakeville Comedies" later becoming stars. Others to become well known later were Wallace Beery, who needs no introduction, and Wesley Ruggles and Lloyd Bacon, now big directors . . .

I have been in Niles several times since and it shall always have a warm spot in my heart. You asked me why I don't work in pictures and make the world laugh and be happy. Well, I have retired. Yes, sir. That is until I get near greasepaint. A whiff of that and I can emulate any proverbial old fire horse at the sound of a fire bell!

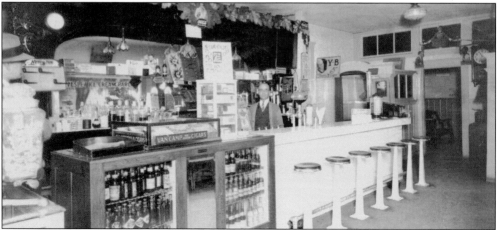

Prohibition between 1919 and 1933 meant that ice cream parlors and soda fountains replaced saloons, and the Wesley Ice Cream Parlor was such a place. In the glass cases are a wide variety of bottled drinks such as brands of cola, ginger ale, and orange crush, and items such as cigars and pipes in the case above. The wall leaf decoration is Coca Cola advertising. (Courtesy Maurice Silva.)

School trustees break ground for the new Niles Grammar School in 1939 that required the seismic standards of the 1935 Field Act be met. This school was to face north towards Second Street, looking towards the Niles Veterans' Hall, which was dedicated in 1930 and designed by father and daughter architects Henry and Mildred Meyers. During the school's construction, classes were held in the hall across the street, as well as in some of the wings of the old school that were phased in their demolition. Pictured, from left to right, are Ben Murphy, unidentified, the clerk of the board, and principal Dixon Bristow. (Courtesy Kely McKeown.)

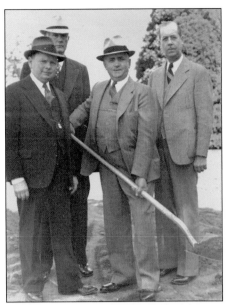

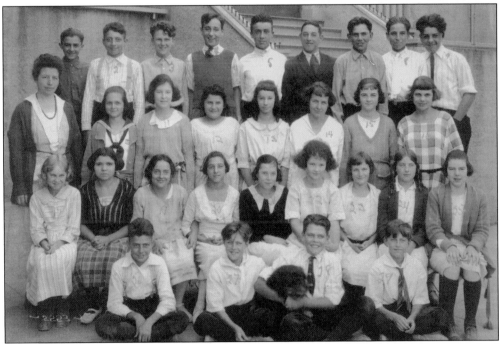

In this seventh-grade class picture, Carol Overacker sits with her class by the steps of the third Niles Grammar School. Carol was always careful to label her grammar school pictures with each name, and they are listed just as they were written. Pictured, from left to right, are (front row) Vernon Bonnett, Morrison Green, John Bunting (with dog), and Marshall Green; (second row) Edna Wellington, Mary Miller, Theresa Di Guilio, Lillian Cesari, Doris Flaig, Hazel Dillon, Josephine Champion, Louise Mitchell, and Carol Overacker; (third row) Miss Bunker, May Walpert, Margaret Moore, Marie S., Helen Andrade, Sophie B., Lillie Jones, and Mamie Perry; (back row) Alfred King, Lawrence Avilla. Miner Macey, Marino, Tony, David Cesari, Norman Rose, Edward Enos, and George Olivera. (Courtesy Overacker Collection, MLH.)

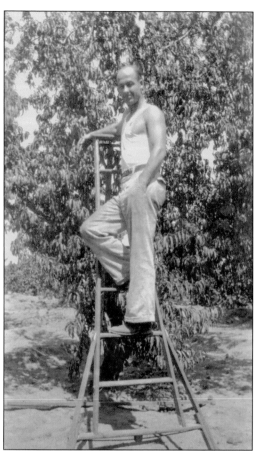

Joe Svoboda is seen here working in the orchard using a three-legged fruit picking ladder, a common tool in every orchard and garden. In later years Carol Overacker married Joe Svoboda. She inherited the Overacker family house and orchards on Mission Road at Walnut Avenue. (Courtesy Overacker Collection, MLH.)

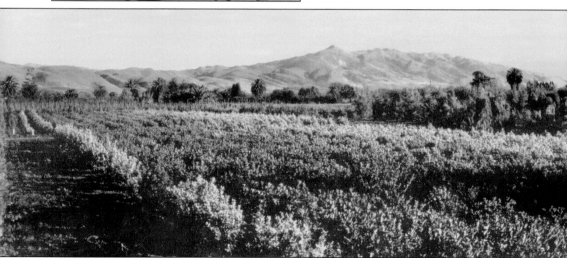

This image shows Mission Peak viewed from the California Nursery Company growing grounds in the 1920s. This particular photographer was Russell Angel, a relative of the John MacDonald family, who lived on the nursery grounds. Mr. McDonald began as bookkeeper but also became a horticultural expert, leading the Spring Bulb festival tours and becoming a noted breeder of narcissus. (Courtesy Julianne MacDonald Howe.)

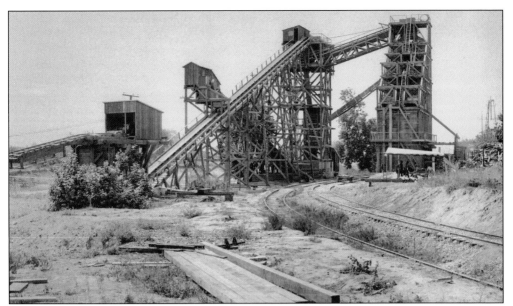

The Pacific Aggregates gravel operations of William Ford were large scale by the 1920s; the track in the right foreground was essential to the bulk of the operations. The 1878 Thompson and West Atlas map shows that this rail access to the gravel banks goes back a long way, even before the transcontinental railroad was completed, providing a local source for the rail beds in Niles Canyon in 1869. These gravel pits are recognized as the earliest gravel mining operation in California.

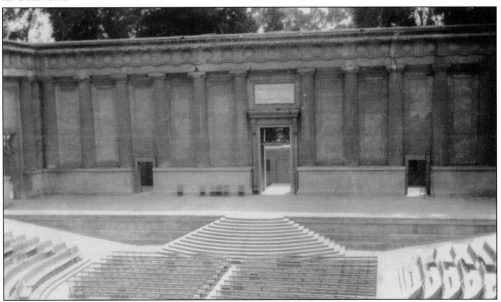

William Randolph Hearst Greek Theatre in 1903 was one of the first new structures designed by John Galen Howard at the University of California at Berkeley. This 1927 photograph shows its early use of reinforced concrete, a specialty of the assistant supervising architect Julia Morgan. The custom gravel grade came from Niles and met her precise specifications. John Galen Howard is also recorded as recommending California Pressed Brick from Niles for the red-bricked secondary buildings on campus. (Courtesy Jill M. Singleton.)

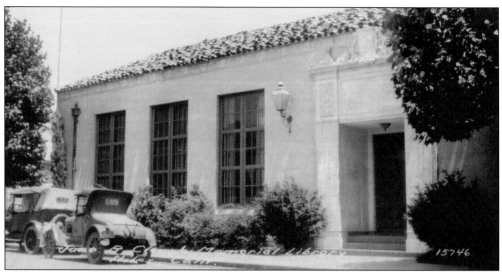

The Jane R. Clough Memorial Library was donated by Mr. and Mrs. William Ford and officially opened on January 14, 1928. Mrs. (Helen) Ford and her mother, Jane Clough, were founders of the Free Library in Niles. The architect was John J. Donovan, who would also design the Niles School in 1939 in the same Spanish Mission idiom. He was also the architect for St. Mary's College at Orinda and Santa Clara University, as well as school and civic buildings in Oakland.

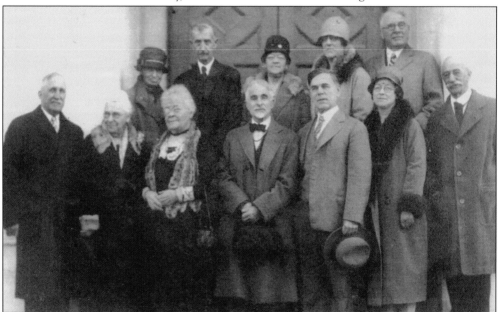

This photograph shows the Niles Library Association on the steps of the newly dedicated Niles library. Niles was organizing in other directions too, and in 1928 there were 1,200 signatures supporting a petition for its incorporation complete with posting of the legal description. Financial concerns may have intervened, but this did not stop a revitalized Niles Chamber of Commerce from stepping up its activities and attracting industry over the next decade. From left to right, are (front row) two unidentified individuals, Lida Thane, Joseph Thane, unidentified, Florence Mayhew Shinn, and Joseph Clark Shinn; (back row) three unidentified individuals, Helen Ford, and William Ford.

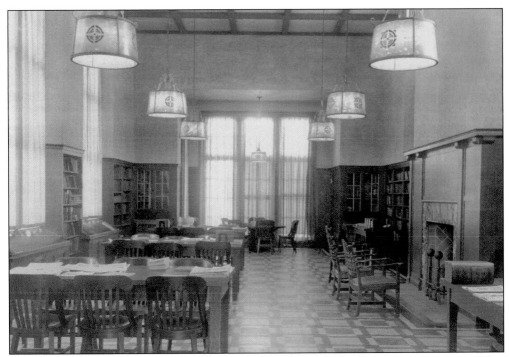

Interior details of the new Niles library include tall multi-paned windows for ample light, high ceilings and good acoustics, an elegantly tiled floor, and a wood-burning fireplace. The hanging illuminated lamps are jewel-like. In addition to the main donations, local businesses donated services such as electrical, plumbing, and landscaping, as reported in great detail in the *Township Register*.

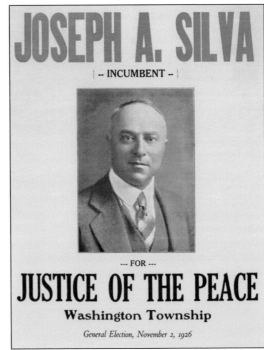

Joseph A. Silva was highly regarded in Niles, and well known at his barber business next to the first Joe's Corner. In 1926 he was elected justice of the peace, a position he held for the next 20 years.

Dick Amyx is shown here at the California Nursery Company grounds near the family home on Rock Avenue in 1926. He entered Stanford that year and completed a degree in classics; he also played flugelhorn in the Stanford band. On weekends home he played in the pit at the film theater while his father played violin. By 1937 he had completed a Ph.D. in Latin at the University of California at Berkeley and started his long career as a world specialist in Corinthian vase painting. He helped found the art history department at Berkeley, was a Fulbright and Guggenheim scholar, and a greatly beloved teacher. His older brother Leon became a painter and well-known teacher at Hartnell College in Carmel, and his younger brother Bob was the leadership and vision behind the Santa Clara County Parks system. (Courtesy Julianne MacDonald Howe.)

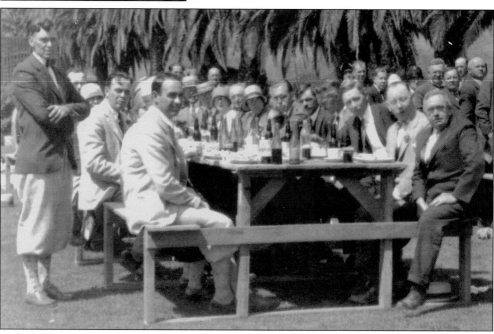

Buford Elmore Amyx is pictured on the far left in plus fours; in front of him is George C. Roeding Jr., also in plus fours. The visiting horticulturalists may be one of the early gatherings of the California Association of Nurserymen held at the California Nursery. Amyx was the general manager at the California Nursery in Niles in the 1930s. He had earlier worked for George C. Roeding Sr. at the Fancher Creek Nursery and was based in Visalia. Amyx later started his own nursery in Visalia and was a regular at the state fair where he was "landscape architect for Alameda County's displays" for several years; he received the Governor's Cup for gardenias in 1937. Buford Amyx is also remembered in Niles for his collection of violins; his wife, Maude, taught piano to Niles children.

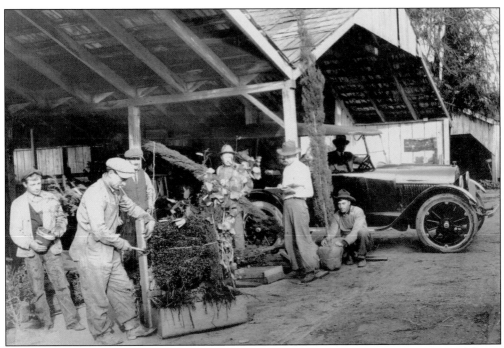

Shown here are nursery workers in the redwood packing shed in the 1920s at the California Nursery. Some of these sheds still stand in the part of the California Nursery Company Historical Park that is leased to Naka Nursery. This is a posed promotional photograph with various steps of the packing process underway. Into the 1930s bare-root plants were still packed in dried tules from the creekside marshes, then rolled in brown paper and tied with string to be sent as a bundle by rail shipment to mail-order customers.

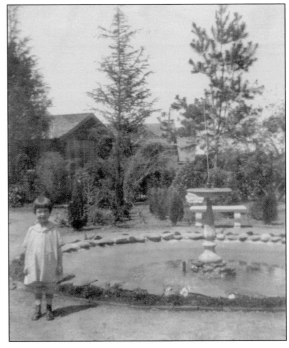

Julianne McDonald's father took this photograph of her in 1926 at the California Nursery Company demonstration garden, north of the tracks at Nursery Avenue. She attended the Niles Grammar School up to 1934 and recalls it as the "wooden school." The walk to school from Rock Avenue took her through the nursery growing grounds, past the nursery cookhouse, and through the Shinn pear orchard. Back then it was "fields and fields of specimen trees, and fields and fields of roses." The employees could pick fruit in the experimental fruit orchards, which were sold around 1940. (Courtesy Julianne McDonald Howe.)

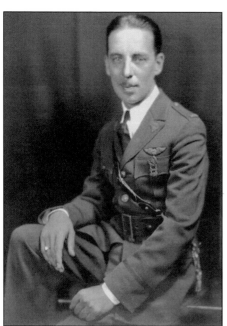

Captain Charles Overacker of March Field, formerly of Niles and son of Mrs. C.B. Overacker of Mission Road, has been selected to fly the U.S. Army bomber which will participate in the opening of the Golden Gate Exposition Saturday [February 18, 1939].

The bomber will circle Treasure Island between 12 and 1 p.m. Saturday and will broadcast over the Columbia network during that time. Captain Overacker and other officers aboard the bomber will be guests of the Fair Saturday and Sunday after which they will return to March Field.

(Courtesy Overacker Collection, MLH.)

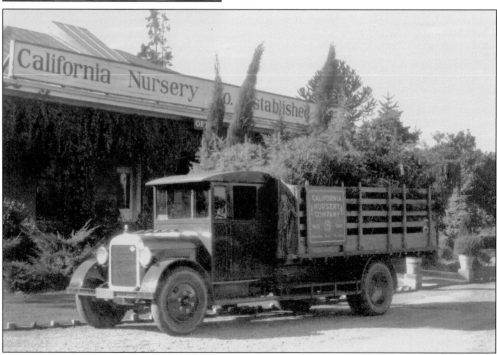

An earlier incarnation of the 1907 California Nursery office building is seen here with its rooftop sign, standing seam metal roof, skylight, and open arches. The tile roof was installed in the 1930s to match the Spanish revival theme of the Vallejo adobe guesthouse transformation and the new garden shop. The Fageol truck loaded with conifers is posed for a nursery catalog promotional picture; these trucks provided long-lasting service to the Roeding family. Fageol trucks were developed in Oakland after the success of the "Fadgl" auto trains at the Panama-Pacific International Exposition in 1915. Later Fageol Motors became part of Peterbilt Motors.

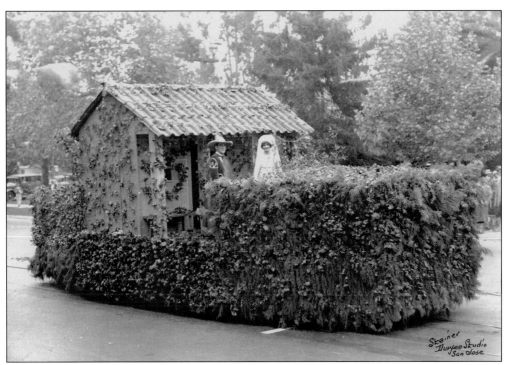

The California Nursery Company replicated versions of the "Old Adobe" as their trademark symbol on all their catalogs and printings. In this photograph, a miniature adobe was carried on a float in a parade around 1939 as well as at the Golden Gate International Exposition itself, in partnership with local brick and tile companies. (Courtesy Bruce Roeding.)

This Kraftile advertisement from the 1930s profiles the "use of Kraftile High Fired Faience to enrich the home with lovely and imperishable colors." Kraft purchased the first lot (subdivided from the then-600 acres of the California Nursery Company) in 1924 as a place to build wood-packing boxes for Kraft cheese. Nothing grew well there, and the Pabrico railroad siding was already in place for the Dickey Mastertile plant next door. It turned out that the poor soil was due to clay deposits on site; within a year Kraft was making tile with the clay and using the box waste to fire the kilns. Kraftile specialized in the finest faience tile and later in structural tile.

CASA IRISADA
HOUSE OF THE RAINBOW

Illustrating the use of Kraftile High Fired Faience to enrich the home with lovely and imperishable colors.

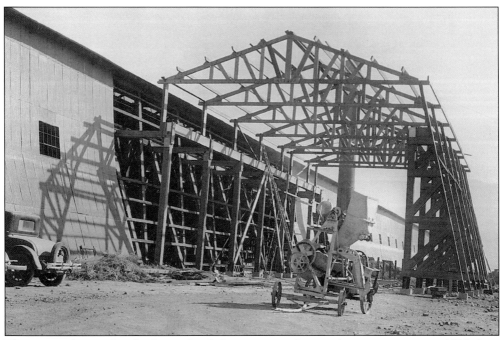

This image depicts Pacific States Steel Corporation plant under construction in 1938. In a few years it was a center for defense employment, supplying the ordnance needs of the U.S. Navy and even being allocated a Navy costs inspector on site. The union offices and the PASSCO employee credit union were headquartered in Niles; PASSCO officials included Ken Steadman of Niles, Oscar Dowe, Frank Carcott, and owners Joe Eastwood and Joe Eastwood Jr. The Steelworkers Organization of Active Retirees still has its offices in Niles in 2004. (Courtesy NESFM.)

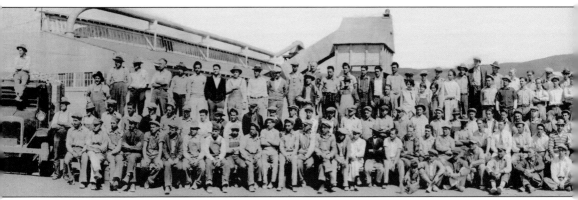

Kraftile employees are pictured here, c. 1930. The office to the left still had the sign for the K&L box making company that led to the creation of Kraftile. Members of the Niles Chamber of Commerce in 1929 and 1930 included the American Garage, Associated Oil Co., Bank of Alameda County, Blue Bird Beauty Parlor, Boitano's Restaurant, Center Restaurant, California Nursery Co., Citizen's Water Company, Dias Construction, Dickey Clay Mfg. Co., Duarte's Groceteria, Florence Restaurant (Italian dinners), Dr. Grau, Greenwood's Pharmacy, Helwig and La Grave, Hadad's Store, P.C. Hansen Lumber Co., International Wood Products Co., Jones and Ellsworth (insurance and realty), Kraftile Co., Murphy and Briscoe, Mutual Store #140, Marble's Service Station, Dr. Morrison, Niles Theater, Niles Cleaner's and Dyers, Niles

Fred Mae Aero Photos of San Francisco was commissioned in 1937 to take this aerial of east Niles, near the present Union City boundary (north is to the left side of the photograph). In the foreground are Dickey Mastertile, the circulation road loop, a Pabrico rail spur, and its extended kiln shed and pits, later the Pacific States Steel site. Kraftile is in the middle ground with its dramatic entry rows of trees. The beginnings of Adobe Acres are behind it to the right; to the left on the other side of the tracks are J. Pessagno and Sons (Interlocking Tile) and the Garden of Allah skating rink. The latter was popular for its big band sound in the 1950s and was where guitarist Black Jack Wayne hosted radio shows.

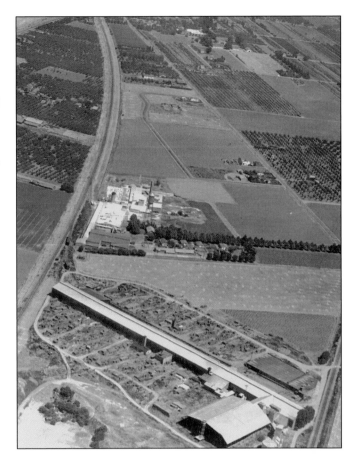

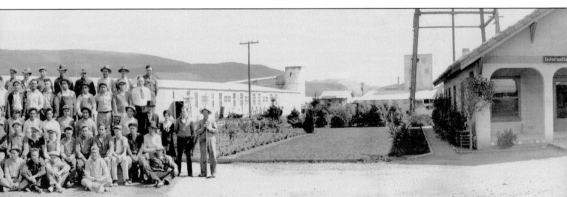

Machine Shop, Ernest Nagli Milk Delivery, Pacific Grill, Pacific Mushroom Co., Pacific Gas and Electric, Paris Sweet Shop, Peerless Grill, Peerless Stages Inc. (bus company), Public Utilities California Corporation, Quality Grocery, Quality Meat Market, Rose Garage, Schuckl and Co. Inc. (fruit cannery), *Township Register*, Vieux Bros., Wesley Hotel, Wesley Ice Cream Parlor, and Western Pacific Railroad. Membership between 1929 and 1945 varied between 27 and 83 members, and in 1940 the annual membership fee was $6. Between 1929 and 1945 the Niles Chamber of Commerce met on Mondays or Tuesday at the Florence Restaurant. In January 1946, International House, soon known as the International Kitchen, opened on Peralta Avenue and became the next meeting place of the chamber. (Courtesy Laurie Manuel.)

Victor and Rose Dias pose outside their bungalow in the 1930s. Their house was built on Third Street around the time of their wedding and around the time the Essanay Studios arrived in Niles. While smaller than the Essanay bungalows on Second Street, this bungalow comes from a similar lineage. Victor worked at Kraftile, and he is one of the people in the large staff photo on the previous page. The garden wall is made of hollow clay structural tile. Widowed for many years, Rose Dias had a smaller cottage built at the back of the lot and rented the front bungalow to provide income. (Courtesy Laurie Manuel.)

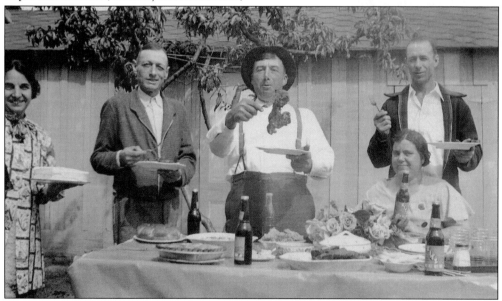

Pictured, from left to right, are Rose Dias, Victor Dias, Mathew Vargas Jr., Annie Vargas, and an unidentified individual. This summer backyard feast was held next door to the Dias home in the Vargas garden by the apricot tree. This is the same group of people pictured in the runabout wedding car of 25 years earlier (see page 38). Roses are on the table and bottles of "Ritz" are part of the meal. (Courtesy Laurie Manuel.)

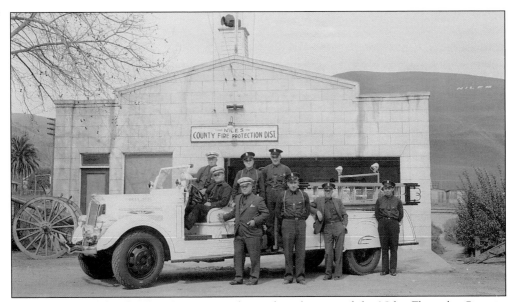

The alarm-topped Niles Fire Station was located to the east of the Niles Flagpole. Captain Alves is seen here showing off his crew and new fire truck. They paid a $1 rent per year to the Southern Pacific Railroad, which owned the land on which the station sat. The old cannons resting to the side were melted down in World War II.

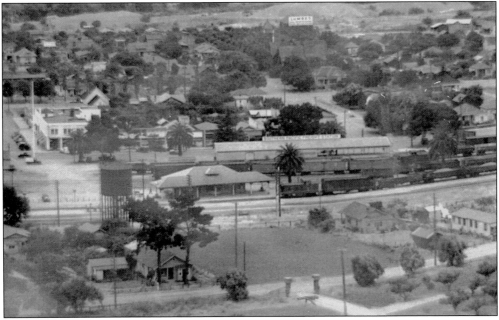

In this view, looking down from the Mayhew to its gates, are the station and rail yard beyond, and the town filling in by the 1930s. The gates to the Mayhew were once located on Vallejo Street, and the olive trees on Vallejo Street were once the boundary plantings for the Mayhew Hotel property. The American garage is to the far right, and the gravel workings on the banks of Alameda Creek can be seen widening the water in the far right background. In the far left background are sheds in the vicinity of the Western Pacific Railroad station, located at the end of Shinn Street and the present location of the Pacific Bus Museum.

Seven underpasses were built as part of the highway system around Niles in 1937 to separate the growing highway traffic from the many rail rights of way belonging to the several railroad companies in the area.

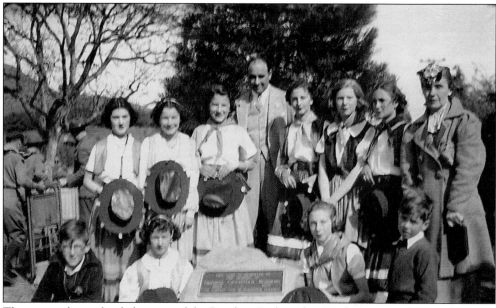

This image shows the dedication of the Roeding Redwood at Washington Park, Mission Road, where the Niles Depot sits today. Scouts set up chairs in the background. This plaque honored the life of George C. Roeding Sr.; in the back row is his son George C. Roeding Jr. , and in the front row, wearing glasses, is Bruce Roeding.

E.E. Dias built this gas station at the entrance to the Sullivan subway in 1938 at the west end of town. Ken Manuel recalls that

The gas station at Sullivan Underpass was a Union 76 station run by Cy Caldeira. I remember my father taking his car to the station to have it lubed and inspected. In those days, brakes, shock absorbers, and other car parts needed to be replaced at frequent intervals, so service station operators has a great deal of normal maintenance work- especially during the war, when it was impossible to get a new car, and items such as rubber tires were in short supply.

Tidewater Associated Oil plant is visible on the other side of the tracks and is still operating today. (Courtesy NESFM.)

The Solon brothers gather at the groundbreaking for a pair of buildings to be built by E.E. Dias in 1938, at the east end of town. One of the buildings became a Tidewater Associated Station (Flying A) and was run by Don Shanks by the 1960s. (Courtesy NESFM.)

Associated Oil Gas Station and the Knotty Pine are set, in this 1937 view, among the palms of the old Palm Drive to the Ellsworth house. These businesses were Frank Rose projects; he appears to have acquired a chunk of the Ellsworth property at the time of the California Highway bypass of Niles in 1937 and developed it at the newly created intersection. (Courtesy Maurice Silva.)

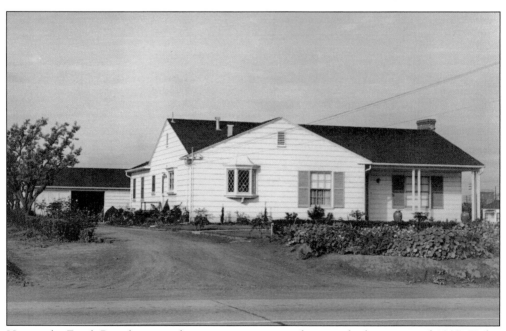

Here is the Frank Rose house at the same intersection, photographed new around 1937. Today the intersection is known as Mission Boulevard (Route 238) and Mowry Avenue (Route 84). (Courtesy Maurice Silva.)

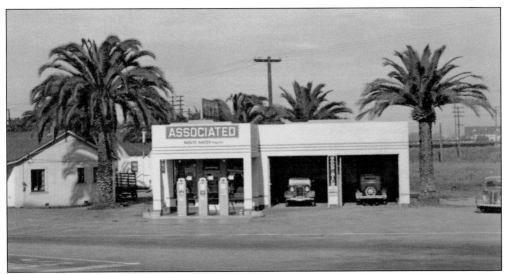

This is another view of the same Associated Oil Station in 1927, which was operated by Monte Mager; Goodrich Tires are for sale. In the 1950s it was Cy and Pike's, and later, on while still run by Pike Souza, it became a Mobil gas station. Back then Mission Road was also referred to as Highway 9. (Courtesy Maurice Silva.)

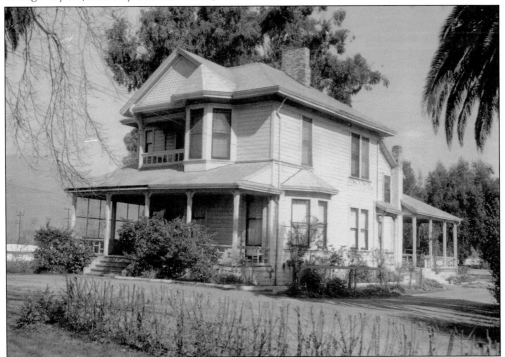

Built in the 1880s, the Ellsworth home was once the place where ladies from around the district came for fundraising teas. Today it has become the Fremont Frontier Motel, 38416 Mission Boulevard, and the gardens are greatly reduced. It became separated from its Palm Drive (its link to the earlier Alameda Creek bridge) when the 1937 highway and bridge bypass were built by the California State Department of Highways over the objections of local residents. (Courtesy Julianne MacDonald Howe.)

Laborers at the California Nursery Company in 1927 prepare Manetti rose cuttings. The row of trees in the background is along the bank of Alameda Creek. Much of the rose growing grounds are part of Quarry Lakes Regional Recreation Area today. (Courtesy Bruce Roeding.)

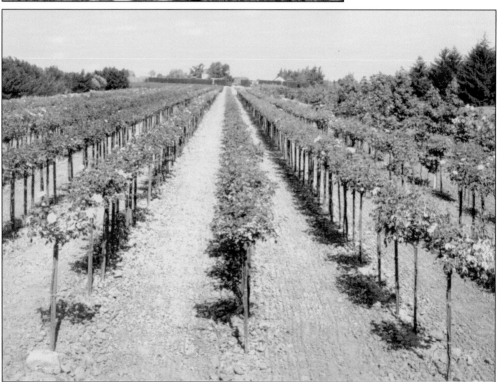

This image demonstrates the same intensively managed rose-growing grounds, budded and raised as standards. Rev. Fong So Yick came to California in 1917, and by 1928 he could afford to buy the Bertolucci farm near Alameda Creek. The family memoirs note that he also did contract work for George C. Roeding Sr. at this date, specializing in the budding of roses.

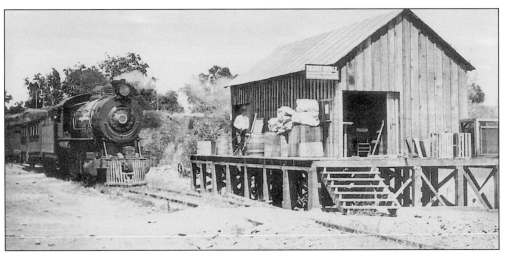

The Western Pacific Railroad, built in 1909, had its Niles ticket station on the south side of Alameda Creek at the end of Shinn Street. The station was later upgraded to have a Niles sign on the roof and to be more inviting to passengers. Traffic was maintained on the line with the Feather River run into the 1960s. The Eberly stop at the low-elevation part of the California Nursery meant that the packing crew could send a load for mail order directly to the Eberly Western Pacific siding, all on nursery property.

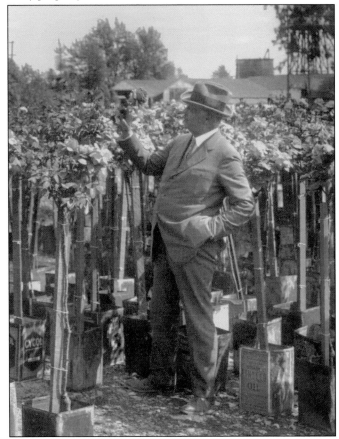

George C. Roeding Sr. is seen here with market-ready standard roses ripe for sale using the pioneering idea of cans. This 1925 photograph was taken by Gabriel Moulin of San Francisco for catalog use and other promotional purposes. It documents the use of metal gallon cans to pot roses for sale, an innovation at the time. Many of the cans were painted a deep Nile green and may still be found today. Harry Rosedale, founder of Monrovia Nurseries, worked for the California Nursery when he first emigrated from Denmark and went on to pioneer growing roses and other plants in containers for all steps of the production cycle.

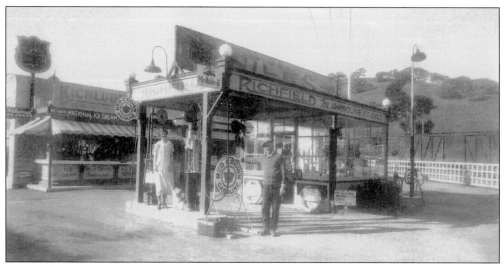

Richfield gasoline station was located opposite the Niles Theatre and run by Mr. and Mrs. Marble. The angled rail spur is busy with rail cars; today this angled property line marks the western end of the west public parking lot on Niles Boulevard. The distinctive hill silhouette behind has changed little since this photograph was taken in the 1930s. In the background is a lunch counter with a National Ice Cream sign above, just below the Richlube sign. (Courtesy NESFM.)

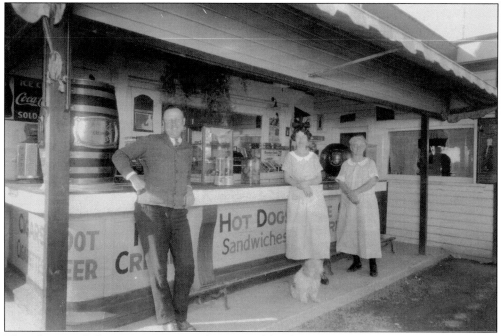

This photograph focuses in on Mr. and Mrs. Marble, their dog, and an unidentified helper. It was cheaper to buy fountain drinks mixed on the spot; here the root beer concentrate is in a cask to the left and orange concentrate is dispensed from the large ball at the far right end of the counter. Coca Cola here was sold only in the bottle. The narrow sideways building shape of the lunch counter can still be recognized, though the root beer and ice cream are just a memory. The address today is 37400 Niles Boulevard.

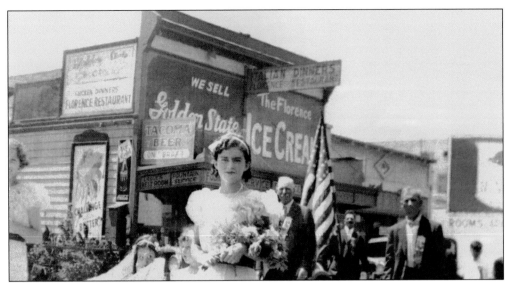

The Florence restaurant, selling Golden State Ice Cream, was photographed here in the mid-1930s during a Holy Spirit parade. "Italian Dinners" appears on the large blade sign that projects high above the wood awning.

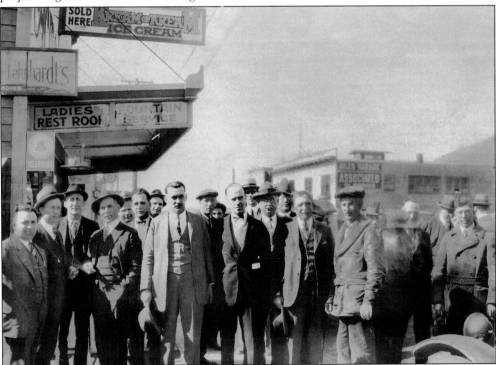

Taken a few years apart, this photograph shows the Florence restaurant selling the Kream of Kream Ice Cream. The Niles Chamber of Commerce is gathered outside; it was reactivated in late 1929. Most of the faces cannot be identified, but Ben Murphy can be seen popping his head up in the back, and the man in the dark-buttoned suit with no tie and no hat is realtor Ned Ellsworth. To Ellsworth, and his partner R.V. Jones, much credit is given for bringing to Niles industries that allowed the economy to grow and thrive over the next decade.

Here the last passenger train leaves the Niles Train Station in downtown Niles in 1941. The Peerless Stages had its depot across the street and had runs to other cities around the bay on a regular schedule, but the automobile was the real competition.

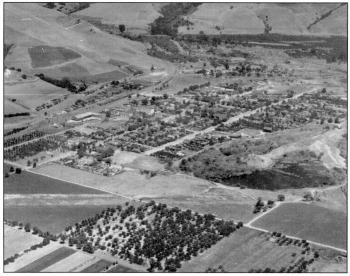

This 1940 view shows the gravel quarries on Alameda Creek and the diagonal trail across the Shinn orchards and fields. The neighborhood in the left middle ground is Duarte Avenue, laid out around 1925 by Frank Duarte. He may have built many of the houses along the street in Spanish Colonial Revival style. Number 14 was his and is still in the family. Behind Duarte Avenue are the orchards of the Hotel Belvoir.

Offering an ideal situation for families who wish a quiet vacation, the Hotel Belvoir, located at the entrance to Niles on the State highway, combines a home-like atmosphere with resort attractions. Within a commuting distance of the bay cities, it is desirable for weekends. Tennis, hiking, nearby riding stables and swimming pools are available. Furnished cottages for year-around residence, and accommodations for travelers and tourists may be secured with home cooking a specialty. Management of Mr. and Mrs. Clark A. Griffin.

—Gladys Williamson for "Home Towns"
Alameda County pamphlet, 1936

Four

OUR HOME TOWN
1941–1972

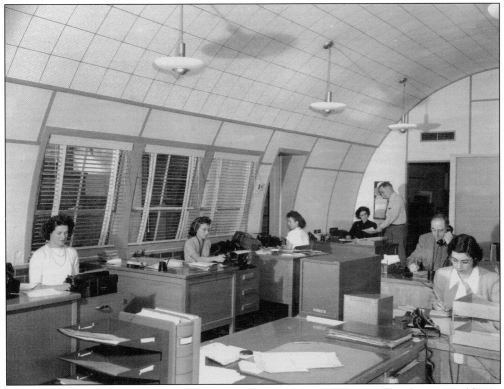

The Kraftile accounting office established itself in a galvanized Quonset hut during World War II, and the building was operational until Kraftile closed its doors in 1996. In addition to its structural tile production during the war, Kraftile became a distributor for a variety of products, including Quonset huts, Pyrolite blocks, and Nukem acid-proof materials. It also produced new Kraftile adhesive products for outfitting ships. From left to right, are five unidentified individuals, John McDonald, and Betty Evans. (Courtesy Julianne McDonald Howe.)

The Pacific States Steel Corporation at Niles specialized in making steel from giant scrap. At full production there were over a dozen types of cranes, including pit cranes, mill ingot cranes, large mill ingot cranes, mill billet cranes, rolling mill cranes, Colby cranes, mobile crane locomotives, Marion cranes, supply cranes, rolling mill cranes, straightener cranes, warehouse cranes, overhead scrap yard cranes, and others, some with booms of 80 feet or more. Established at Niles in 1937, at a time when the railroad companies were selling off their older railcars and steam engines for scrap value, the large steel plant meant that the East Bay was well served for custom steel production for Liberty Ships. Stove plants in Irvington and Newark were retooled to produce war ordnances, and domestic production was suspended. Steelworkers with specialized skills were given war preferment status. It was dangerous work; in the first year of U.S. involvement in World War II, more Americans died working on war jobs at home than serving overseas. (Courtesy Union City Historical Museum.)

The (women's) war services of the Washington Township Country Club listed in the survey book and quoted by Mrs. Foster over the air include: the greatest contribution of all, 50 service men; total hours of service work by members, 116,360 hours (ration board, Red Cross, food conservation); blood donors, 108 pints, which include one 9 pint donor and 4 gallon donors; and bond selling, with $16,075 worth of bonds sold by club members.

—Township Registrar, March 15, 1944

The country club had already sold over $18,000 worth of bonds toward the purchase of a bomber as a federation project. And preliminary reports reveal that the sale of bonds toward the purchase of a Hell-Cat is already oversubscribed.

—Township Register, February 23, 1945

The Pacific States Steel Corporation is a very large plant . . . The Editor has seen their steel go into Government orders for winning the war, and right now they have big orders for every day structural needs of the highest type. Controller and General Manager Marion Newman is in charge of the plant located on Nursery road between Niles and Decoto.

—*Township Register*, June 1953

The 61-acre site of the steel plant was incorporated into Union City in 1959 following the school district jurisdictional boundaries of 1855. Unions represented at Pacific States Steel included the Operating Engineers and the United Steelworkers. At its peak there were over 450 employees, making Pacific States Steel one of the largest employers in Southern Alameda County. The plant closed in 1978 at a time when steel was being made more cheaply in Japan. The giant sheds and stacks were largely dismantled in the late 1980s and toxic waste clean-up began in June 2003. (Courtesy of Union City Historical Museum.)

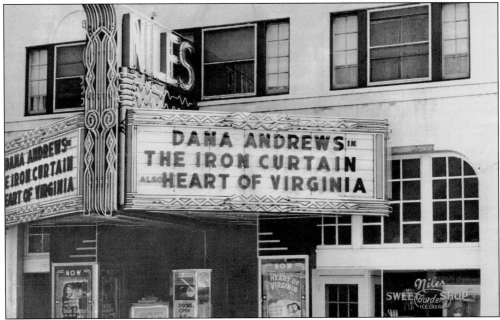

The Niles Theater was the place for first-run movies when it was built in 1924. The marquee and floodlighting were installed in 1934, adding a "Metropolitan Air to First Street in Niles." This first-run showing in 1948 was a double billing of black-and-white movies with mono sound; the feature was a true spy story about defecting to the West, atomic secrets, and the Soviet Embassy in Ottawa during the Cold War. "The show" typically started with newsreels and animated shorts.

Niles Interlocking Tower, built in 1912 by Western Pacific, handled the several intersecting railroad lines on the south bank of Alameda Creek. Orders were relayed from Roseville to direct the freight; over 50 trains a day at the peak. This protocol was replaced by Direct Traffic Control (DTC) in 1984. The much-loved tower was destroyed in 1986, but the "Niles Tower" sign survives in private hands in Niles today. (Photo by Dino Vournas.)

In 1949 Niles Rotary moved its "Big Wheel" sign from its Hotel Belvoir location to the International Kitchen, located in the 500 block of Mowry Avenue. This photograph was taken at the International Kitchen in July 1960 when the gavel was handed from outgoing president Dan Bodily (far right) to incoming president Earl Jackson (holding gavel). Standing behind with the toy helmet is charter president Charles (Chuck) Kraft, the first president of Niles Rotary and head of Kraftile. (Photo by Dino Vournas.)

Betty Vandenburg was photographed as part of the 1944 rose promotion. The California Nursery Company was selected as the West Coast growing grounds for a new Meilland hybrid tea rose during World War II. On V-E Day, May 8, 1945, the Roeding family arranged for a flower of "Peace" to be given to each delegate at the first United Nations conference in San Francisco. The message with each rose was, "This is the rose 'Peace' which received its name on the day Berlin fell. May it help all men of goodwill to strive for Peace on earth for all mankind." (Courtesy Bruce Roeding.)

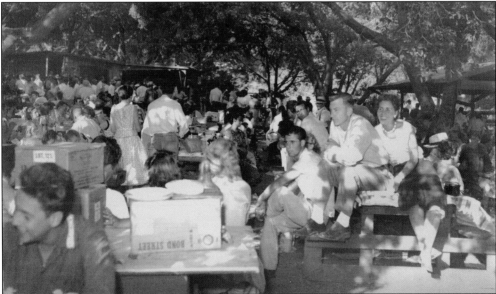

Shown here is a company picnic at one of the picnic grounds in Niles Canyon during the 1950s. Niles Canyon Picnic Grounds at the mouth of the canyon was one of the first developed in the canyon; W.W. Dugan was the proprietor in 1897 and J.B. Bernard in 1898. The picnic grounds had many conveniences, including a dance pavilion, a restaurant, a bath house, and a landing for small boats. In the 1950s it was called Elderberry Park and had a swimming pool. Bernard also leased property from the railroad at the mouth of Stony Brook Creek and, in 1901, founded Fernbrook Park, where he built a 65- by 125-inch dance pavilion. Peter Mosegaard leased the property near the Southern Pacific Station called Farwell, renamed the park Stonybrook, and developed it into the most famous canyon park. John Philip Sousa and his band played at the picnic grounds in Niles Canyon in 1915 while at the Panama-Pacific International Exhibition. (Photo by Dino Vournas.)

Judge Edward A. Quaresma had offices in the upstairs of the Ellsworth Building and was "doing a fine job" according to the *Washington News* in May 1947. He served on the U.S. Board of Economic Welfare and returned to Niles to be elected justice of the peace in 1946 for the combined area of Niles and Centerville. He became the first municipal court judge for Fremont in 1959 and a founding director of Fremont Bank in 1964.

The Niles Electric float was in the sesquicentennial county parade hosted at Niles in 1953; John Brahmst preserved the truck for such occasions. In 1958 John Brahmst was president of the Niles Chamber of Commerce and later of the Fremont Chamber of Commerce. (Courtesy Al Lopez.)

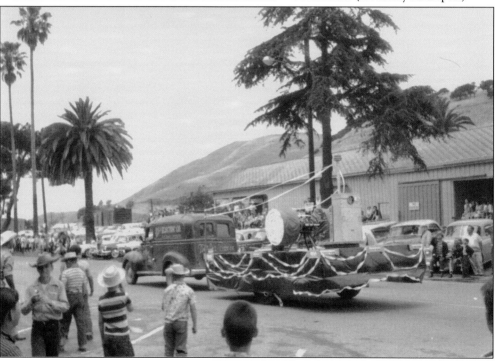

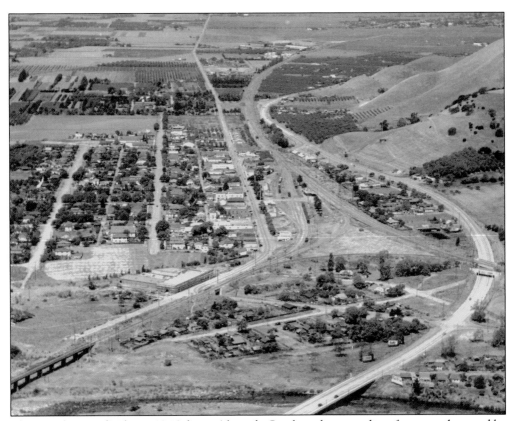

This aerial view of Niles in 1946 shows Alameda Creek in the immediate foreground crossed by the 1937 bridge, and the chopped-off ends of Vallejo and Sycamore Streets near the creek bank. California modernist architects Wurster Bernardi are completing the new Schuckl cannery at the intersection of First Street and Niles Canyon Road.

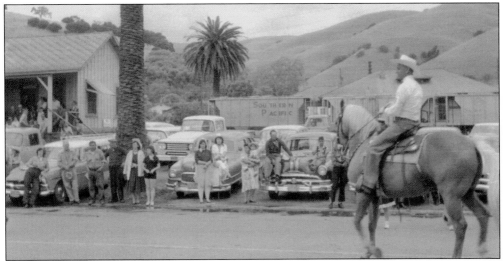

A cowboy Western theme had been used for the parade celebrating 150 years of Alameda County. The well-maintained Southern Pacific freight depot had a wrap-around loading dock, a popular place from which to watch the parade. (Courtesy Al Lopez.)

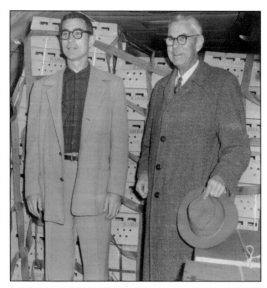

Arthur C. Kimber is pictured with his father, John E. Kimber (poultry genetics pioneer), and a container load of Kimberchiks. These chicks were bred for disease resistance and premium egg quality characteristics. The aircraft is a high-speed Constellation plane developed by Lockheed during and after World War II. Art Kimber flew B-25s in the war as a pilot, flying 39 combat missions. (Courtesy Art Kimber.)

Here a load of Kimberchiks finds its way onto an American Airlines airfreight jet.

One of the world's most modern scientific poultry breeding plants is at Niles, all work at the Kimber Poultry Breeding Farm being organized along strictly genetic lines with a highly trained staff of twenty. More than 2,000,000 eggs have been weighed as they were taken from trapnests; over 200,000 precision tests of egg quality made; and all females in 500 families are being held . . . There are 6,000 birds being housed in thirty buildings on forty acres. Shipments made all over United States, to China, Hawaii, the Philippines, South America, Mexico and Canada.

—Gladys Williamson for "Home Towns"
Alameda County pamphlet, 1936

Vargas Plateau lies above both Morrison and Niles Canyons, and is the former Rankin Ranch that is now part of East Bay Regional Park District. It is on the alignment of the Bay Area Ridge Trail now being strung together as public access points become available. Here an *Argus* newspaper photographer captured a rare snowstorm in the 1970s. (Photo by Dino Vournas.)

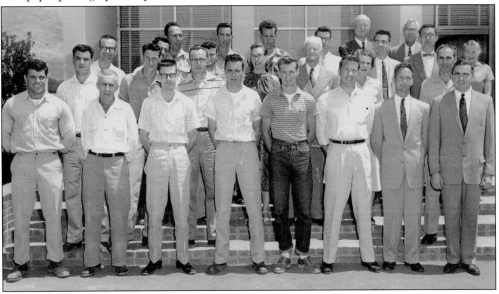

Admiral Nimitz was photographed with the Kimber staff that served overseas in World War II and in Korea in front of the new Kimber offices, now the Christian Community School at 39700 Mission Boulevard. The Kimber administrative building was one of the first concrete tilt-up construction projects in this area in the mid-1950s. From left to right are (front row) Alex Bernard, Rufus Cauthron, Norm Coit, Herbert Cartwright, unidentified, Clifford Kimber, Vernon Miller, and Dr. Walter Hughes; (second row) Alfred Bernard, Billy Cartwright, and Bob Brooks; (third row) Mervin Telles, Manuel Azeveda, Jack Scott, unidentified, Admiral Nimitz, unidentified, and George Rodrigues; (fourth row) John Powell, Jess Landrom, M.C. Cartwright, Robert John Kimber, Dr. George Farnsworth, Art Kimber, and Lottie Kimber; (back row) Dr. John Nicholls and John E. Kimber. In 1958 the Nimitz Highway was opened at Fremont, and John E. Kimber made the inaugural speech at the ribbon cutting. He worked with Mrs. Nimitz on the San Francisco Symphony board and proposed the highway's name.

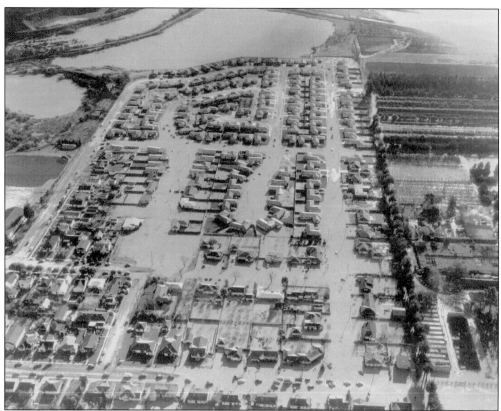

The last big flooding in Niles took place on December 24, 1955. The Pacific States Steel Mill was like an island, and the California Nursery growing grounds, as well as the new Niles subdivisions, were flooded. Rowboats were used to rescue stranded people. (Courtesy Dr. Walter Hughes.)

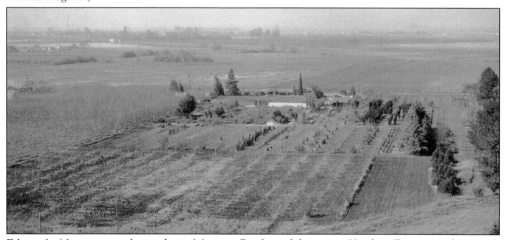

Edenvale Nursery was located on Mission Boulevard between Kimber Farms to the north and the Niles Poultry Farm (Medonca) to the south. Frank Serpa purchased Edenvale from founding nurseryman C.E. Wilson and joined the retail chain Master Nurseries around 1959. Frank Serpa was part of the nominating committee for Fremont's Landmark Tree list in the 1970s. (Courtesy Nelson Kirk.)

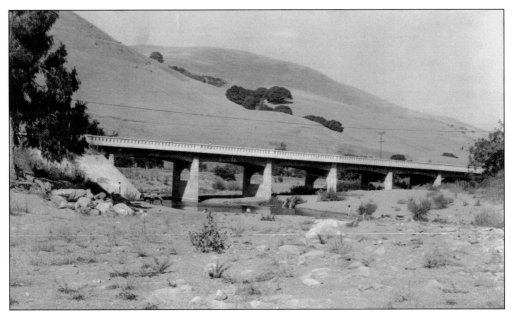

Stanley Bridge carries Niles Canyon Road across Alameda Creek on the access road to the California Pressed Brick factory. Later the business became California Pottery (1930) and had 75 employees and production of 17,000 tons per year. Most recently it was the Mission Clay tile factory. Sewer pipe made by California Pottery was sent all over, including septic tanks for airway stations in the South Pacific in the 1940s. In 1999 futuristic scenes for *Bicentennial Man* with Robin Williams were filmed here. (Courtesy Union City Historical Museum.)

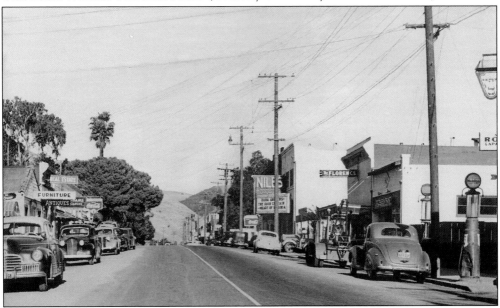

The concrete Niles Theater opened in 1924 with a red velvet curtain, bird of paradise carpeting, 500 padded permanent seats, and an orchestra pit for fiddle, piano, and drums. In 1953 owner Bill Helms sponsored the Apricot Queen event in Niles, and movies were 50¢. At one point patrons were even allowed to bring in hamburgers from the lunch counter across the street. The onions proved too much for Bill Helms, and the practice was discontinued.

Vallejo Mills School, pictured here on Arbor Day in 1958, was a junior high school for the Niles School District (1955–1964). Here, eighth graders are in charge of a tree planting project out front. The school's colors were black and yellow, and the school mascot was the California condor. In the 1970s, this junior high became an elementary school. In 1993 the elementary school students voted to make turquoise the school color and the dolphin the mascot. In 1994 Principal Kalb acquired a dashing dolphin costume and parent Dave Edwards composed the "Dolphin Song," in the name of Spirit Day. Pictured, from left to right, are two unidentified individuals, Jack Brasselle (eighth-grade teacher), Barbara Musick (at the microphone), Helen Carmichael (in tight skirt), Buddy Lampley, Herb Goss, and three unidentified individuals.

The Bee Pageant at Niles Grammar School was an annual event held in the auditorium every spring. Boys were bees and girls were dressed as raindrops, and the audience enjoyed accompanying sound effects. Teachers at that time included Mrs. Engle, Mrs. Oxboro, Mrs. Curran, Mrs. Keller, Mrs. Enos, Mrs. Murphy, and Mr. Click. (Courtesy Kenneth P. Manuel.)

Maj. Gen. John F. Stewart Jr. is a third-generation Niles resident, as his mother was a member of the Vargas family of Third Street. Their family home was on First Street, now called Niles Boulevard. John attended Niles Grammar School and was co-valedictorian at Niles in 1953 with Cathy Oxboro. A graduate of Washington High School and on its first swim team, he completed a bachelor's degree in English at San Jose State University and a master's degree in international relations at Johns Hopkins University. He became one of the first officers to enter the newly designated Military Intelligence (MI) Branch in 1967 and was honored for his MI leadership in 1997. (Courtesy Army Intelligence Museum, Fort Huachuca.)

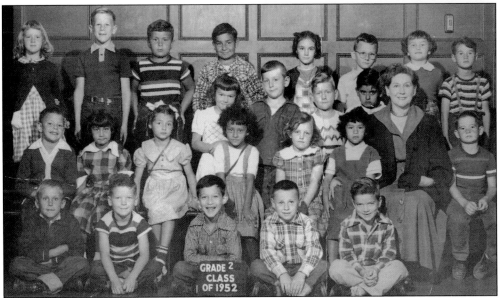

Class pictures were taken in the auditorium at Niles Grammar School in 1952. Ken Manuel, the child with glasses in the back row, wrote the following:

> Most of the boys I grew up with went into one of the military branches. You must remember that at that time, there was a universal draft for all males 18-35. Many boys joined so that they could choose the service they wanted. I was commissioned an Army 2nd Lt out of ROTC at San Jose State University in 1967 . . . I was sent to Vietnam in June 1968 and assigned to Long Lines Battalion - North of the First Signal Brigade. Our unit provided fixed station telecommunications for the northern part of South Vietnam.

(Courtesy Kenneth P. Manuel.)

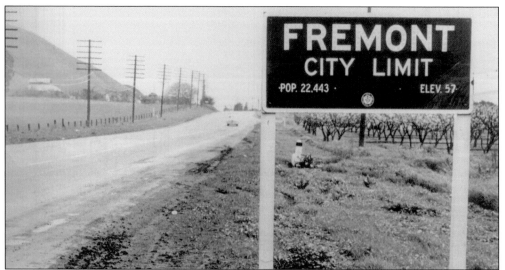

Here stands the Fremont entrance sign at Niles in 1956; the population expanded tenfold over the next five decades and filled these orchards near King Avenue with homes.

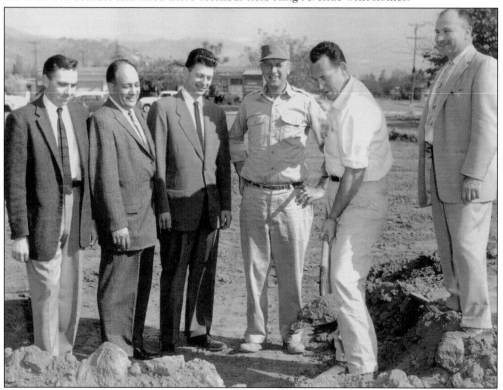

This photograph shows the 1960 groundbreaking for the Hacienda School, part of the Niles School District. The first phase of school construction cost $170,900, and a planned administrative section was never built. The school was innovative in its early use of classroom aides, and served kindergarten and the primary grades. From left to right are Dr. Walter Hughes, M.R. Cancellier, C.B Vorwerck, John Trollmann (building superintendent), Jack McClellan (board clerk), and Anthony Scafani (district superintendent).

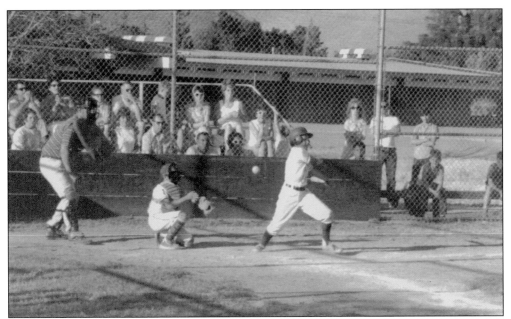

The baseball field at Hacienda School was popular with the residents of the Hacienda neighborhood, including these parents. Principal Robert Lewis remembers cows and pigs on the playground, and using dried cow patties to mark bases for softball games. During the week, gravel trucks exited from the adjacent quarry at eight-minute intervals in the early 1960s; eventually the noisy traffic was routed away from the school.

Here the Niles Veterans' Hall is photographed from under the shady camphor trees in front of Niles School in the 1970s. In 1958 the left section of the building replaced a plaza and provided a full dining room facility. The flagpole was retained and the entire facility was seismically strengthened and restored in 2002 for use by veterans and for rental use by the community. (Photo by Dino Vournas.)

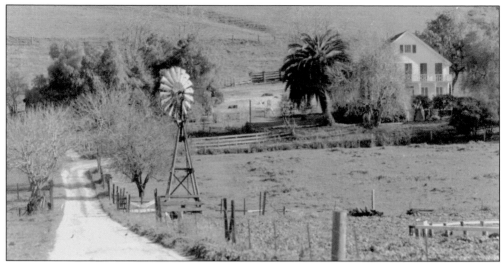

This house was built in the 1850s for Henry G. Blasdell, who was elected governor of Nevada in 1864. After just a year, the home was acquired by John and Rachel Taylor, who built a granary and barn for a large wheat farm in the mid-1850s. Osmond and Clara Slayton bought the ranch in 1876 and Earl and Edith Mackintosh inherited it in 1945; the family owned the property for over a century. An equestrian riding circle can be seen in the right foreground in 1966. The buildings still stand today. (Photo by Julianne McDonald Howe.)

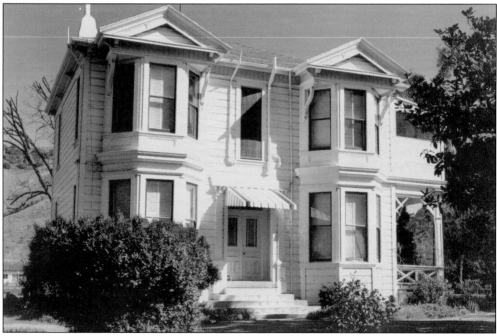

This is the Pickering House as it looked in 1966. It faced the original Mission Road, now called Overacker Road, which ran immediately parallel to the railroad. Mr. Pickering ran a large newspaper conglomerate in San Francisco, and invested in an orchard and house in the country at Niles after his son was born in 1890. Mr. Pickering died shortly afterwards, leaving the newspapers in trust. Martha Barker owned the house from 1945 to 1995, and it is now the Martha Barker Community Center. (Photo by Julianne McDonald Howe.)

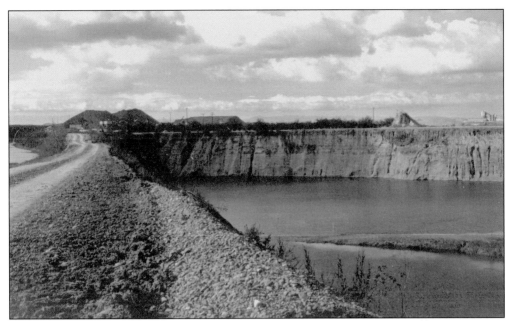

The Alameda County Water District graded the original steep walls of the Kaiser and Lonestar Quarry Pits in a major re-engineering project in the late 1990s to increase the groundwater recharge capacity of the lakes. (Photo by Julianne McDonald Howe.)

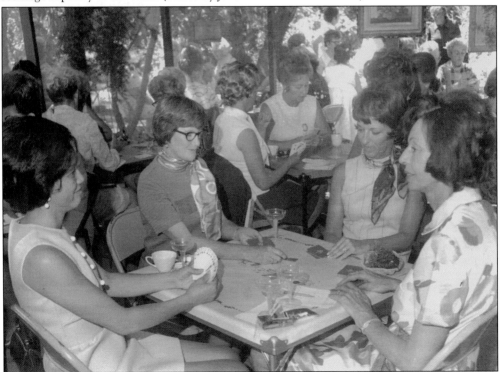

The Washington Township Country Club held a bridge luncheon fundraiser for the new Shinn Historical Park in the 1960s. This popular event was held both at Castlewood and again at the chairperson's home on Riverside Avenue in Niles. (Photo by Borden.)

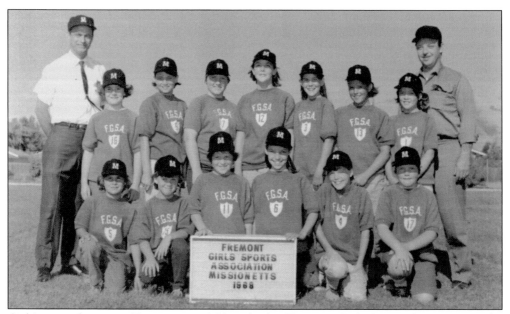

Girls' sports began in Fremont in 1966 with the Fremont Girls Sports Association. The Missionettes were from Mission and Niles, and they won the championship in 1968. Pictured, at the sides of the team, are Manager Bill Fontes (left) and Coach Clyde Comfort (right). The team members are, from left to right, (front row) Debbie Dutra, ? Melton, Judy Guerrero, Holly Melton, and Grace Brown; (back row) Laurie Manuel, Jean Fontes, Karen Brown, Vicki Peterson, Judy Campbell, Nancy Kay, and Debbie Wood. (Courtesy Laurie Manuel.)

The large 1924 Niles Theater was gutted by fire in 1959, demolished in 1968, and the site became the present gravel parking lot next to the Edison Theater that still stands at 37417 Niles Boulevard. On November 1, 1913, Mr. and Mrs. MacRae opened the Edison Theater, and they lived in one of the apartments upstairs. It is this earlier theater that became the home of the Niles Essanay Silent Film Museum in 2004. (Photo by Dino Vournas.)

Five

DOWNTOWN NILES
1972–2004

Niles Community Park began in the 1960s around the time when the U.S. Army Corps of Engineers began the redesign of Alameda Creek as a flood-control channel. The latter was completed in 1972; the park plan was largely in place by the late 1990s. The first gravel pits in California are here at Shinn and Grau Ponds. The U.S. Gypsum Plant is on the other side of the creek, at the end of Shinn Road. The plant produced gypsum board for around 40 years before ceasing production. (Courtesy Michael McNevin.)

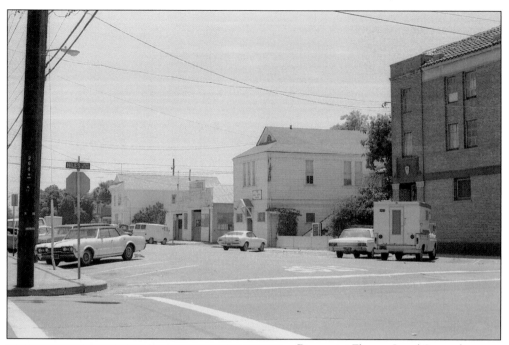

Domenici Flats at J and Second Streets were the first rental flats venture in Niles, undertaken in 1911 by successful market gardener Manuel Domenici. In 1916 daughter Zelmera entered San Jose Normal School (now San Jose State) to train as a teacher. By 1929 son Creed built the machine shop with sliding garage doors, next to Iron Horse Lane. Their mother, Mary Domenici, was related to Essanay cameraman and actor Rollie Totheroh. (Courtesy Philip Holmes.)

The tiled ice cream counter still stands at Joe's Corner, complete with original faience tile from Kraftile. Two of the wood bars inside are also original to this Niles icon, built by Joseph Silva in 1932 when he was 57 years old and in his seventh year as justice of the peace. The twin storefronts are distinctive in their use of faux-wood concrete lintels and brackets, designed by George Ellinger, an architect of Oakland. (Courtesy Michael McNevin.)

Bob Temple purchased the Wesley Hotel in 1972 and is seen here at the bar among the macramé plant holders and other rustic decorations of the Iron Horse Saloon, known for its nightlife and live bands at the time. The hangout of film crews from 1912 to 1915 and an ice cream parlor from 1919 to 1933, today it is the popular "Thyme for Tea" and is known to be visited by the "Red Hat Ladies." (Photo by Dino Vournas.)

Pictured here are Smith's Furnishings and other businesses at the west end of Niles Boulevard in 1972. The Moose Hall to the left was the first custom-built post office in Niles, and was later replaced by one built by Joe Silva in 1932 on J Street. This hall is now the home of the Steelworkers Organization of Active Retirees.

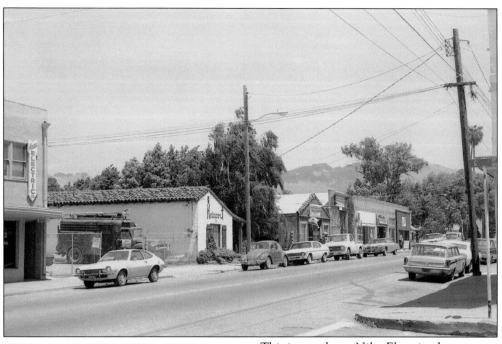

This image shows Niles Electric, the Hairport, and Devil's Workshop at the west end of Niles Boulevard in 1972. An old Niles Electric truck is parked next to the Hairport. The Brahmst family still runs the Niles Electric business.

Niles Electric sponsored the Braves of the Niles-Centerville Little League that played at the Hacienda field for many years; the team was also known as the Niles Electric Braves. Michael McNevin wears No. 13 in the mid-1970s, a time commemorated in his award-winning song enshrined at the Baseball Hall of Fame in Cooperstown, New York, in July 2004:

The Pride of Niles-Centerville Little League. This is the all-American saga of a ground ball going through the skinny legs of a little leaguer, complete with bleachers full of parents, new cut grass, and the heart of a kid. A funny and nostalgic vignette of our favorite past time.

(Courtesy Michael McNevin.)

The Niles-Centerville Little League Braves are pictured in 1972 in front of Hacienda School; the team won the league championship two years later, 18–2. The McNevin family was able to cycle the uniforms through several boys. The coaches here are Mick Thomas (left) and Jack McNevin. The players, from left to right, are (front row) Mike Thomas, James Hill, Michael McNevin, Tony Kirchener, Johnny Lopez, and Robert Stefani; (back row) Pat McNevin, Gary Tuggole, Greg Hill, Harold Branch, John Hill, Mark Silvierra, and Tommy Lutz. (Courtesy Michael McNevin.)

The wood-frame Niles Court House (1915) and the concrete Niles Jail (1911) are pictured here in 1971. They continued to be used for their original purposes into the 1950s when Niles was a county center. Around the time of Fremont's incorporation in 1956, the justices of the peace were Ralph V. Richmond (later county supervisor), Joseph Silva, and Anthony Quaresma.

Held the last Sunday in August, the Niles Antique Faire began under the name Niles Flea Market in 1964, and produced t-shirts to go with the event.

The annual flea market happens on the last Sunday in August, filling up the whole downtown with booths and over 100,000 antique seekers. This was heaven to us. If we weren't running around looking at priceless junk, we were making a mint by selling parking spaces. Danny began that enterprise, and it made us money for several years. We'd get up early in the morning on Flea Market Day, about 3:00 a.m., and rope off the gravel lot at the old torn down '76 gas station. We weren't sure who owned it, but no one ever kicked us off. It was a gold mine—right on Main Street at the entrance of the Flea Market. Our competition was the big lot across the street at Rebello's Market, which was always run by the little league. They had a nice, big paved lot, so we had to work hard for our customers to get them into our crumby illegal lot. As a car came idling down the street looking for a place to park, both sides would call to them and hold up a cardboard sign that said "Parking—$2". If the car began turning into their lot, we'd yell at the car one more time, flip our sign over to read "Parking—$1.50". More often than not, they'd park in our lot. We made more money in one day doing that than in a month of delivering papers.

—Michael McNevin, *Harbinger*, Winter 2000

(Photo by Dino Vournas.)

Here orchards off Peralta Avenue are being flood irrigated in the 1970s. The Nunes family owned the last operating u-pick apricot orchard until the late 1990s. (Photo by Dino Vournas.)

In 1984 the Niles Train Station was moved down Mission Boulevard to Nursery Avenue, where it was taken across the tracks at Nursery Avenue, moved to Washington Park, and oriented towards the highway. Jim's Niles Market was previously Russell's, Rebello's, and the site of the Essanay Studios before that. Since then it has been Kesley's, Mrs. Bentley's, and Mikey's Market. (Courtesy Phil Holmes.)

The last footing of the bridge across Alameda Creek at the foot of Vallejo Street is pictured here in 1990 with Louis Di Guilio. The bridge was the pride of Niles when it was built. Constructed by the Pacific Bridge Company of Frear Street, Oakland, it was 414 feet long, 18 feet wide, planked, 20 feet above water, and built for $14,000. (Courtesy Phil Holmes.)

Joe's Corner is the backdrop for the antics of a competitor in the Charlie Chaplin look-alike contest, one of the events at the Essanay Days in 1996. Joe's Corner was a pool room during Prohibition. In 1932 Joe Silva redeveloped the site with the present building and the small post office behind. The Moderne blue metal and neon sign dates from 1932; the name survives from the previous era. (Courtesy Jill M. Singleton.)

This two-story landmark building was constructed in 1930 and replaced the previous wood-frame IOOF building. It was designed by George Ellinger of Oakland, who also designed Joe's Corner. Irish immigrant and railroad worker Jeremiah Lynch built the small false-front buildings to the right in the early 1890s. One of the first tenants was Joseph Roderick's Tonsorial Parlor; Roderick was also constable until 1913. Lynch's saloon operated here by the early 1900s but became a confectionery during Prohibition. (Courtesy Jill M. Singleton.)

Michael Connors built a two-story brick building in 1909, the first one in Niles. Connors Hall was upstairs then and showed the first movies in Niles. Downstairs was the Pastime Saloon, a billiard hall, and Darrow's Bakery. A Darrow descendent recalls that Wallace Beery hung out with the son of the family while Beery was directing in Niles with Essanay in 1915 and 1916. Later the upstairs hall was removed and the Peerless Bus Stages made this their depot. (Courtesy Jill M. Singleton.)

The Niles Merchants train car has often been the backdrop for staged events. The "Gunfighters of the Old West" are an award-winning group based in Fremont specializing in the "historical drama of western frontier." Here they prepare for a re-enactment at the Charlie Chaplin Days hosted by the Niles Merchants in 1996. The Gunfighters performed at the Broncho Billy Silent Film Festival in 2003 and 2004, a three-day event held every June and hosted by the Niles Essanay Silent Film Museum since 1998. Pictured, from left to right, are Stanley Coleman (second from left) and Karen Baldwin (right). (Courtesy Jill M. Singleton.)

Jim Light of Niles rides in the July Fourth parade of 2002 on his 1999 Harley Davidson Super Dyna Glide Sport. Jim and his wife, Carol, live in the first Southern Pacific train depot building. Also at one time the home of the Niles Free library at the corner of I and Second Street, the depot was moved to Riverside Avenue in Niles and has put down permanent roots there. (Photo by and courtesy David Munn.)

The Niles Essanay Silent Film Museum entry in the 2002 parade was the much-loved Niles fire truck, cared for by the Roeding family since 1937. From left to right, the silent action on the float included David Kiehn (with vintage movie camera), Colleen Perez, Irene Perez, and Bruce Roeding (driving in cowboy gear). The picture was taken on Second Street looking across the street from the Niles Jail, where Essanay movie scenes were filmed in early 1914. (Photo by and courtesy David Munn.)

Dale Hardware began in 1955 on the other side of the Lonestar Quarries south of Niles. While physically part of Centerville, Dale Hardware is part of the heart of Niles in its support of community events and in sustaining the publication of the *Niles Herald* since 1996. Garth Smith and his team help Niles celebrate the Fourth of July with a parade entry in 2002. (Photo by and courtesy David Munn.)

Mitchell McLeland of the "Highland Warriors" was one of the dashing foot entries in the Niles 2002 July Fourth parade. Another Scot, Niles piper Steven McElhany played for student graduations at Vallejo Mills Elementary School in 2001 and 2002. A member of the World Champion Prince Charles Pipe Band and an award-winning soloist, he participated in the 2003 World Championships in Glasgow, Scotland and played "Amazing Grace" at the rededication of the Niles Memorial Flagpole on June 12, 2004. (Photo by and courtesy David Munn.)

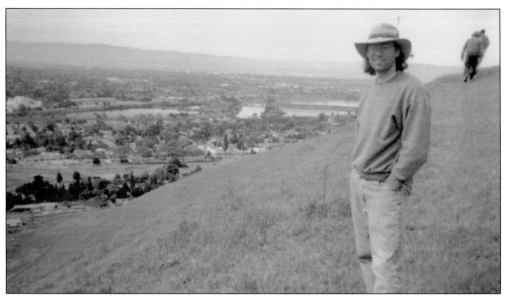

Quarry Lakes Regional Recreation Area is viewed here from Niles hill with Michael McNevin up by the Niles Landmark Letters. Purchased with park bond monies approved by voters in 1988, Quarry Lakes was opened to the public in 2000. The lakes were re-graded from the massive gravel pits quarried in the postwar boom, and the last pit closed in 1995. The re-grading allowed the pit sides to maximize their potential to recharge the aquifers of the Niles Cone that underlie the area; these underground reservoirs are essential to the Alameda County Water District's water supply. (Courtesy Michael McNevin.)

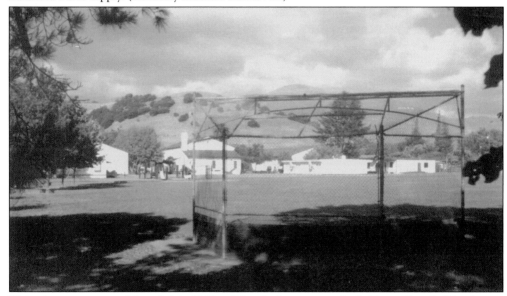

This view was captured from behind Niles School, showing its playfields and baseball backstop, as well as the ponds, trees, and trails of Niles Community Park. Derrell McKinley "Bud" Harrelson, who was born in Niles in 1944, went on to play shortstop for the New York Mets in 1965. Another famous athlete who graduated from Niles is Kristi Yamaguchi, who was the 1992 Olympic gold medalist in ladies figure skating and the winner of numerous championships. (Photo by and courtesy Michael McNevin.)

The Niles Canyon Railway is operated by the Pacific Locomotive Association. Volunteers have been rebuilding track down Niles Canyon towards Niles since 1987, getting as far as Vallejo Mill by the early 1990s. The passenger steam train is scheduled to be in Niles proper after new bridges are completed over Mission Boulevard (Route 238) in 2005. (Photo by and courtesy Michael McNevin.)

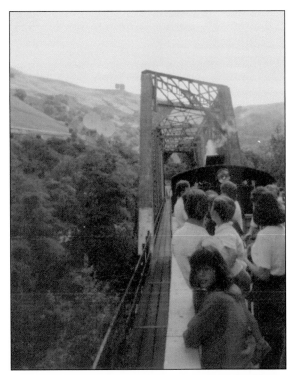

Fabridams on the Alameda Creek Flood Control Channel were a novelty when installed in the early 1970s to divert Alameda Creek into recharge ponds. Alameda Creek Regional Trail, on the levees of the flood control channel, was the first set of trails to be built on levees as part of any U.S. Army Corps of Engineers project. This is the only traffic-free trail that connects the hills of the East Bay and the San Francisco Bay, as well as linking to the Dumbarton Bridge. (Photo by and courtesy Michael McNevin.)

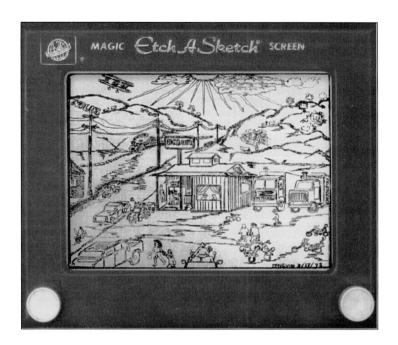

Above is an image of Big Daddy's Cook House at the mouth of Niles Canyon, and below is the Vallejo Mill baseball backstop. (Both courtesy Michael McNevin.)

If you had a bike, the world got larger. You could ride towards the canyon to Big Daddy's Cook House, the old Vallejo Mill, and the "secret sidewalk". As we got older, we'd follow the Alameda Creek down to the steep and deep quarry pits, where the gravel barges and 50 foot cliffs made for good jumping, until the quarry cops chased us off in their blue trucks.

—Michael McNevin, *Harbinger*, Winter 2000

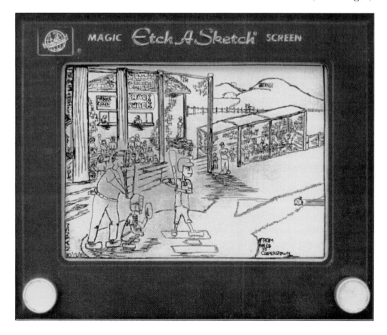

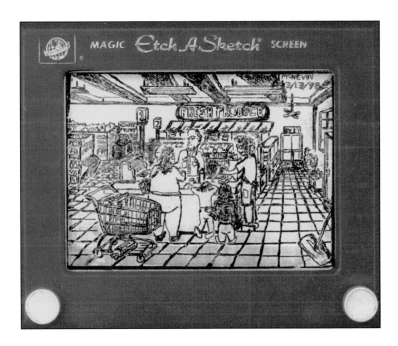

Above is Rebello's Grocery Store on Niles Boulevard in the 1970s, and below is the Niles School playground. (Both courtesy Michael McNevin.)

I bag the groceries at store #3, I wear a white shirt and tie, no-one faster than me. I'm the youngest bagger here, I work four shifts a week. I wet down the produce, and I bail up the cardboard. And I mop up the eggs when they drop 'em on the floor. And I fetch all the shopping carts in front of the store.

—Michael McNevin, "Bagger," *Sketch*, 1998

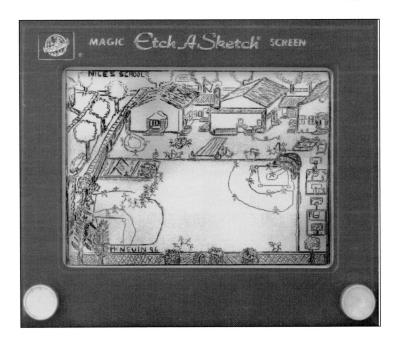

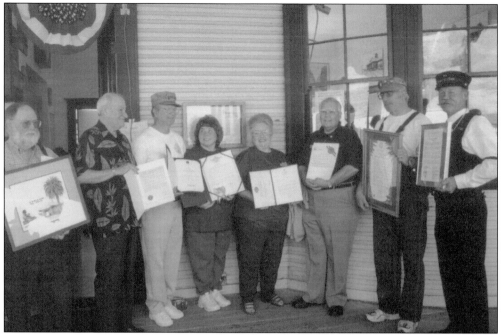

Here Niles supporters accept proclamations on the centennial of the Niles Train Station on October 20, 2001. Pictured, from left to right, are Larry Telles, local artist; Bob Wasserman, Fremont city councilman; Ed Bingle, Niles Depot Historical Foundation; Marie Dear and Shirley Filgate, Niles Merchant Association; Al Nagy, Newark city councilman; Stanley Keiser, Niles Depot Historical Foundation; and Greg Schindel, "The Train Singer." (Courtesy Niles Depot Foundation.)

In the 1990s, Louis Gomez was a popular Chaplin look-alike for the Niles Essanay Silent Film Museum. Here he is at one of the Niles Dog Shows, also known as the Pooch Pow Wow and Canine Convention, an event that welcomes pooches with or without a pedigree. (Photo by Carol Spindler, courtesy Niles Dog Show Committee.)

This photograph captures a library celebration song performed by Niles Elementary School students at the Veterans' Hall in Niles in 2003. Pictured, from left to right, are Claire Petersen, Martin Munn, Claire Normoyle, Andre Vernot, David Berke Masterson, Natalia Neira, and Owen Coumou. The singers were directed by Cathy Petersen. (Photo by Chris Knapp, courtesy Natalie Munn.)

Bruce Cates, dressed as alter-ego Broncho Billy, welcomes State Librarian Kevin Starr to Niles on the occasion of the 75th anniversary of the Jane Clough Memorial Library. Bruce Cates is also the senior technical advisor on the Niles Essanay Silent Film Museum board and the Gold Spike event organizer. Kevin Starr is the much-lauded author of California histories and one of the state's treasures. (Photo by and courtesy David Munn.)

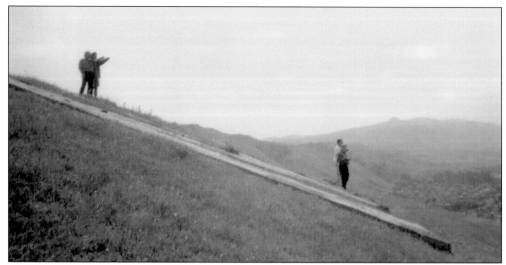

The Niles Landmark Letters are marked as such on every U.S. Geological Survey map of Niles. The Niles Junior Chamber of Commerce first put up the letters in 1926 as part of a national trend to combine boosterism and navigation markers for the new field of aviation. The white painted letters were covered with dirt during World War II. Pictured here with Mission Peak in the distance, from left to right, are Don Dewey, Julianne Pagan, Kerry Knight, and Ed Frakes. (Photo by and courtesy Michael McNevin.)

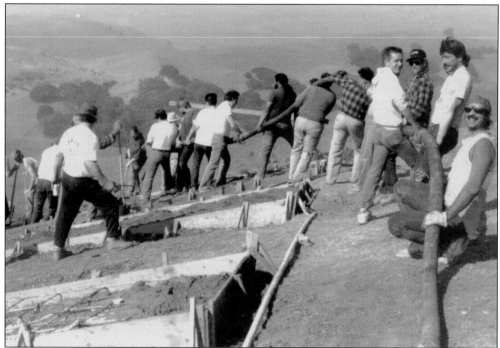

Reconstruction of the Niles Landmark Letters in 1990 was completed by Niles volunteers, led by Paul Figoni. Forms were built, rebar positioned, and a full-scale concrete truck came from Hayward to pour the gargantuan letters. Pilots still use this landmark to instantly verify their location. The panorama of Niles and the greater Bay Area stretches below. On a clear day, you can see Mount Tamalpais visible on the north horizon. (Courtesy Phil Holmes.)

Six

Town Gardens
1856–2004

The California Nursery Company plant catalogs were produced for close to a century, the last one being printed in the late 1960s. Some of the trees that were not sold still grow today as part of the arboretum in the California Nursery Company Historical Park on Niles Boulevard at Nursery Avenue. The "Eclectic Forest," hidden in the back of the California Nursery Historical Park, is a remnant of the nursery's growing grounds alongside a replanted heritage orchard. (Photo by Marvin Collins.)

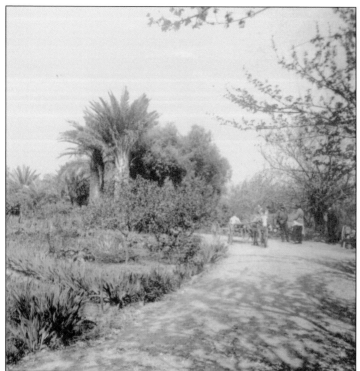

The "circle garden" at the Shinn Ranch was laid out in 1876 and recorded in this photograph of 1915 long before it was cut back to become a park in 1962. Gardens have grown here since 1856. The Shinn children, including the future naval commander Allen Mayhew Shinn, appear on the pony cart in the distance on the circular drive. In 1937 he was designated a naval aviator; by the end of World War II he was commanding Carrier Air Group 89 based aboard the U.S.S. *Antietam*. (Courtesy James Shinn.)

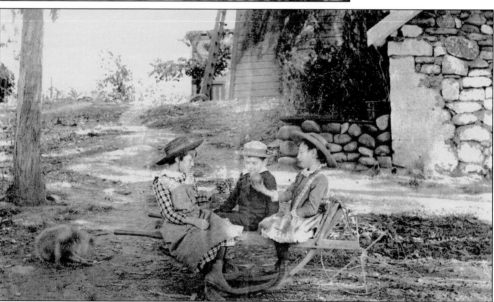

This cyanotype was taken by Oliver Ellsworth in 1887. The Ellsworth family purchased the A.J. Severance farm (famous for its pedigree livestock) in the 1880s, and later greatly expanded the farmhouse. In the background is the Severance tank house and nearby a milk house of river stone built in 1851. Oliver went on to graduate in law at Hastings in 1911 and was later elected mayor of Piedmont. Pictured, from left to right, are Florence Mayhew, Stuart Chisholm (who grew up to be a landscape architect working on large estates back east), and Carrie Ellsworth, who died young.

The beautiful garden wedding of Emelita Mayhew (Florence's youngest sister) and Bill Cobb at "the old Shinn Place," on October 26, 1912, welcomed 200 guests. The bridesmaid on the left is Edna Sharpe, then living with her grandmother Emilie Chittenden, the owner of the Belvoir Hotel. Edna acted in films at the Essanay Studios in 1912 and 1913; she previously worked as an actress in Oakland.

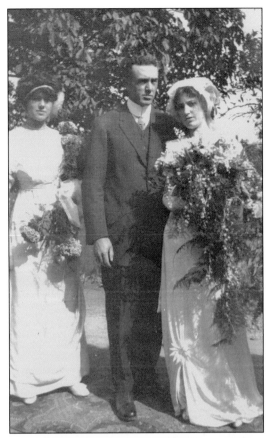

The 1907 bungalow-style president's summer home is still in use at the California Nursery Company Historical Park. It is in the portion of the park, near Mission Boulevard, that is leased to Naka Nursery and the family of Shig Nakamura. Local legend has it that it was designed by Maybeck. It is true that in 1907 Maybeck published a booklet for the Hillside Club of Berkeley advocating leaving the city for the country and designing homes to blend into the landscape—this shingled bungalow meets those criteria. (Photo by Marvin Collins.)

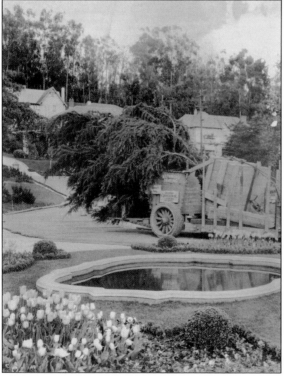

This gateway led to the San Rafael home, called "Fairhills," that was owned by A.W. Foster, the head of Crocker Bank. It was photographed here as part of a MacRorie and McLaren photograph series. The California Nursery Company supplied the plant materials for this project. George C. Roeding Sr. acquired the photograph series in 1925 for use in his catalogs and promotional articles.

This landscape job of the California Nursery Company in Piedmont (in conjunction with landscape architect Arthur Cobbledick) involved moving large tree stock for instant effect. Cobbledick also designed the "Morcom Amphitheater of Roses" in Oakland, for which the California Nursery Company supplied the rose stock. It was one of several East Bay rose gardens and cascades built as a Works Progress Administration project in the late 1930s.

Here Lida Thane serves tea to friends in her garden around 1920. In 1911 Mrs. Thane acquired title as a gift from her father Judge Tilden, and she expanded the house in Craftsman style. In 1927 she conveyed it to her realtor daughter Laura Thane Whipple, who then commissioned a lush garden design from the California Nursery Company. The well-hidden house can still be glimpsed at the north end of Overacker Avenue. Mrs. Lida Thane is on the right.

These large tree boxes are a 2002 restoration of the original California Nursery Company tree boxes. These oaks were originally boxed for moving offsite. In 1970 the trees were left resting here when the site became part of the California Nursery Historical Park. Over the years the trees rooted in place and the original redwood boards and tension wires were "borrowed" to build generations of forts for children in adjacent gardens. (Photo by Marvin Collins.)

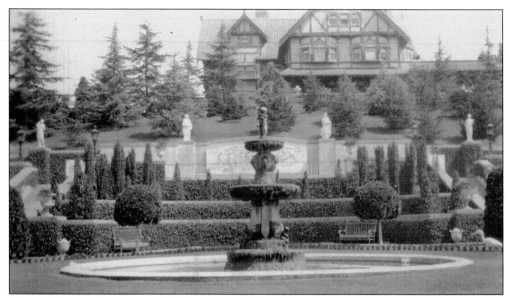

The gardens at this estate in Piedmont were planted by the California Nursery Company. In 1921 George C. Roeding Sr. commissioned landscape architects Theodore Paine and Ralph Cornell to develop a concept for a "Gentleman's Estate" for him at the California Nursery property at Niles. A plan was produced but never implemented. Roeding and his wife continued living on La Salle Avenue in Piedmont throughout the 1920s, and son George C. Roeding Jr. built a more modest home at the nursery in Niles, near the end of Second Street.

These nursery rows of English yews have taken on a life of their own, becoming their own "wild garden" at the California Nursery Company Historical Park. Two slender Irish yews stand behind the 1907 California Nursery Office building that was modified by architect Edward Foulkes in 1930. They mark the path used to connect directly to the row of greenhouses, bunkhouse, cookhouse, and kitchen garden where apartments now stand. (Photo by Marvin Collins.)

This is one of the grand original Canary Island palms planted by John Rock in 1884. Some of the palms in the Niles area today are protected homes for owls; the California Nursery Company Historical Park has been a rich source for the annual bird count list of the Ohlone Audubon Society for decades. Niles has a fine collection of cold hardy palm varieties for Northern California. (Photo by Marvin Collins.)

This hillside garden once grew above the "secret sidewalk" in Niles Canyon. The "Big Freeze" that began on December 20, 1990, killed the Mediterranean-type plants that had survived happily in the Niles area for more than 50 years. In this garden, plants such as Meyer lemon, avocado, and bougainvillaea died back to the ground. Amazingly, the latter two grew back more vigorously than before. Around 1894 a similar cold event occurred, and the prize orange orchards of Niles disappeared forever.

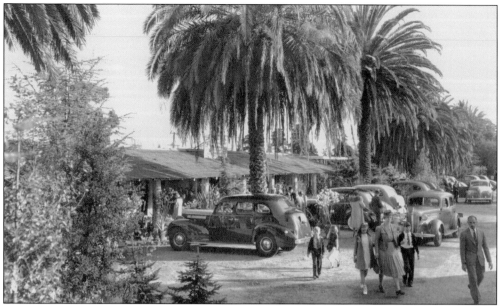

The Annual Spring Bulb and Flower Show was held every April at the California Nursery Company until the 1960s. In 1939 visitors traveled from around the Bay Area in their sedans to visit the garden displays in Niles, as seen here. The "garden shops" of the California Nursery Company were a new idea in the 1930s; in fact, they may have been the first retail chain of garden shops in Northern California. The Niles Wildflower and Art Festival is now held mid-May. The gardens at the Shinn and California Nursery Company Historical Parks are both open year-round. (Courtesy Bruce Roeding.)

Only in Niles! In 1998 civic improvements in Niles included new sidewalks and other streetscaping. In 2002 a custom series of banners by graphic designer Michael Manwaring of San Anselmo were installed. The idea of metal silhouette banners is unique to Niles and celebrates the creativity of the generations of working people that have brought Niles its richness and vitality. More information about Niles history, shops, and events may be found at www.niles.org, www.nilesfilmmuseum.org, www.ncry.org, and at www.museumoflocalhistory.org.